C000204916

Victorian &
Edwardian
Dorset

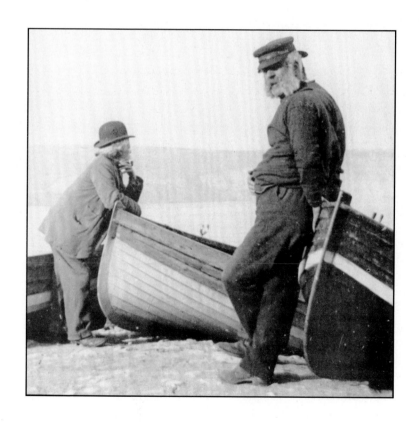

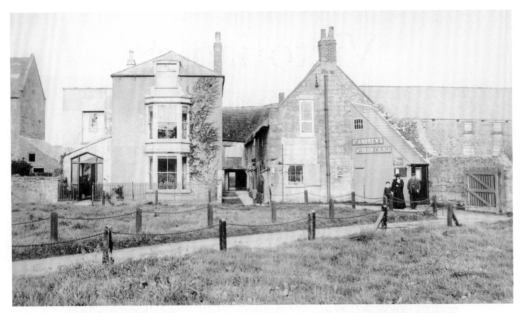

ST ANDREW'S MISSION CHURCH, WEST BAY

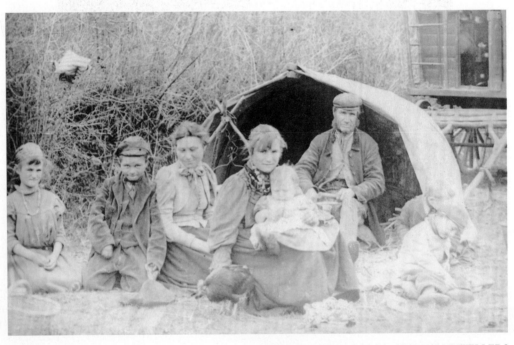

ROBERT JONES AND FAMILY, VAN DWELLERS

Victorian &
Edwardian
Dorset

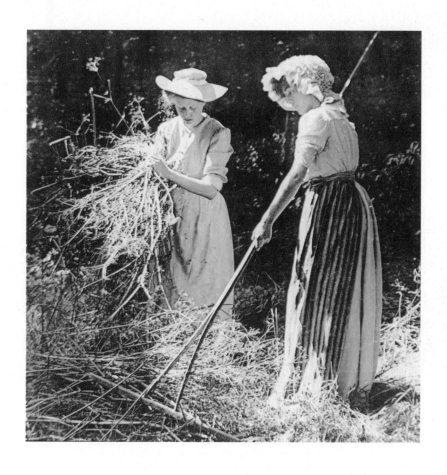

Simon Rae

AMBERLEY

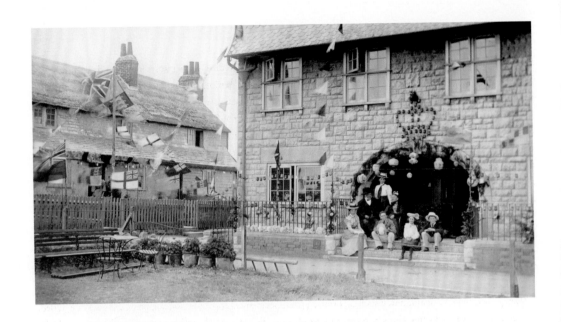

First published 1993 under the title *Dorset of 100 Years Ago*
This revised edition first published 2008

Amberley Publishing
Cirencester Road, Chalford,
Stroud, Gloucestershire, GL6 8PE

© Simon Rae, 2008

The right of Simon Rae to be identified as the Author of this work has been asserted in accordance with the
Copyrights, Designs and Patents Act 1988.

All rights reserved. No part of this book may be reprinted or reproduced or utilised in any form or by
any electronic, mechanical or other means, now known or hereafter invented, including photocopying and
recording, or in any information storage or retrieval system, without the permission in writing from the
Publishers.

British Library Cataloguing in Publication Data.
A catalogue record for this book is available from the British Library.

ISBN 978-1-84868-027-2

Typesetting and origination by Amberley Publishing
Printed in Great Britain by Amberley Publishing

'The past is a foreign country: they do things differently there.' Dorset a hundred years ago would certainly have borne out L. P. Hartley's famous dictum from *The Go-Between*. Sifting through the wonderful photographic legacy bequeathed to us by the Victorians, I was struck by many instances of 'foreignness'—the clothes, to begin with. How did they bear it? Even on the sea front, people were swathed like Egyptian mummies. Then the lack of motor vehicles, regular cairns of horse droppings insisting that despite the transport revolution of the railway, this is still a horse-drawn society. But as with any society, turn-of-the-century Dorset was by no means static. While the forerunners of our World Cup winning women cricketers were playing the national game on the grounds of Sherborne Ladies' College, so old men who went to work in the fields in smocks were drawing on their pipes and reminiscing of the days Thomas Hardy commemorated in his novels. As the new century dawned, volunteer militiamen were exercising around the camp at Blandford, only a few short years before the war no one could have prepared for. And wherever a photographer set up his tripod, people, especially the children, would stand open-faced, to have their images immortalized. There was time to stand and stare; the pace of life was far more leisurely than it is today. 'Never such innocence again,' as Philip Larkin put it in *MCMXIV* his moving portrait of pre-First World War England.

'Never such poverty again, never such ignorance again, never such appalling housing again', it could be added, and certainly we should not allow a sepia mist to obscure the very real hardships experienced by the majority of the population. Life lived under Victorian values was not easy. Theirs was a rigidly structured and deferential society (though never quite as deferential as those being deferred to would have liked—the 'servant problem' was a perennial issue for the middle classes). Penury was the lot of vast numbers, and the threat of penury was a stern corrective to any stirrings of independence or insubordination. In the Victorian heyday, farm labourers touched their hats to keep a roof over their heads (and even then there was no safeguard against summary eviction see p.22.

It has been my pleasure to travel to that foreign past of Dorset a hundred years ago. Dorset has always been a special county for me—for a few years in the early seventies I spent idyllic holidays at Langton Matravers—and it has been wonderful re-acquainting myself with the county during the compilation of this book. Availing myself of the freedom and privileges we take so much for granted, I have driven many happy miles—to Shaftesbury, to Sherborne, to Sturminster Newton, to Dorchester, to Wareham, to Lyme Regis, to West Bay—glorying in

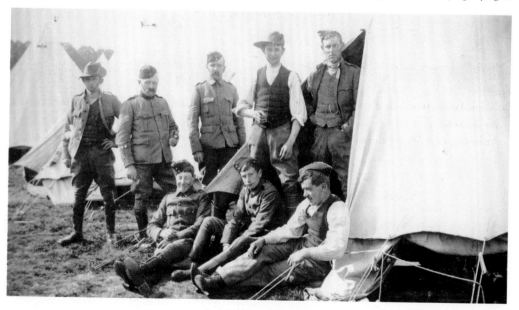

YEOMANRY CAMP

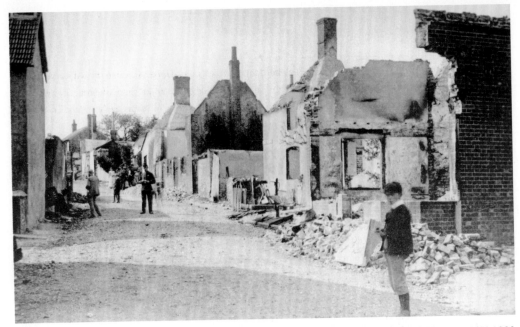

SIXPENNY HANDLEY AFTER THE GREAT FIRE OF MAY 1892

the incomparable Dorset countryside; delighting too in that extraordinary coastline, and, it must be admitted, enjoying the occasional siesta on one of Dorset's many hospitable beaches.

Throughout my tour I have been fortunate to meet with unfailing enthusiasm and helpfulness. My thanks first to two willing and hard-working researchers, Felicity Goodall, who located some exceptionally valuable material for me in the County Record Office in Dorchester, and Michael Adams, who aided me with his local knowledge and helped me sort through several thousand postcards. It's possibly worth mentioning in this context the fire at Sixpenny Handley of May 1892. The fire began in the blacksmith's forge, and fifty-two buildings, including the Methodist chapel and forty-six occupied cottages, were destroyed. A hundred and eighty-six people were made homeless by the blaze, 'the greater portion of them', according to a contemporary account, 'losing everything, even down to their clothing.' The hapless blacksmith in question was Michael's great-great-grandfather.

I did the bulk of the work for this book in three Dorchester institutions—the Dorchester Reference Library, the County Record Office, and the Dorset County Museum. While extending warm thanks to all the members of staff who assisted me, I should mention by name Nick Lawrence and Shirley Wickham of the library, Chris Woods of the County Record Office, and Val Dikker of the museum. Due to an arrangement with Richard de Peyer, the Curator, I took some seventy-five photographs from the museum's superb photographic archive (I have drawn heavily from both the Powell and Pouncy collections) and Val was my guide through this cornucopia, tirelessly helpful and inexhaustibly patient. Any success the book has will be very largely due to her. I owe her a special debt of gratitude.

Private individuals have also given me invaluable assistance: Barry Cuff not only gave me the run of his extraordinary postcard collection, but introduced me to Dorset's 'other' dialect poet, Robert Young; David and Janet Garnish introduced me to Barry Cuff and also let me look through their postcards; Graham Ovenden came up with three wonderful photographs showing contrasting aspects of the Dorset coast; Arthur Watson invited me down to his restaurant on the coast at West Bay and sent me away not only well fed but with a splendid cache of rare prints into the bargain. He also pointed me in the direction of Jerry Moeran, whose Studio Edmark, Oxford, supplied me with more coastal views. Finally, and not for the first time, Tony Lurcock made useful reading suggestions and generously lent me books. To all these, and to everyone else who has helped in the compilation of this book, my heartfelt thanks.

As Geoffrey Grigson remarks in his Festival of Britain guide to Wessex, 'Dorset is a county with a very sharp spice of the exceptional—curious, quickly changing scenery, a curious coast, and a sense of being cut away from the rest of southern or western England'. This remains as true today as it did in the early 1950s. So it would have been a hundred years ago.

If I were to choose one representative photograph from the following pages it would be that of the ploughman on the cliffs above Swanage (p.14). Dorset is a county of such contrasts. The life of Dorset people has always been bound up with the land and the sea.

The land for the most part is good rich farmland, but in the closing decades of the last century Dorset was suffering from the agricultural depression that was affecting the whole country. Land values were low, rents were low, wages were low. As with all chains of economic hardship, the hardest hit were those at the bottom. Before our period, in 1834, the Tolpuddle martyrs were persecuted for their attempt to force wages up from seven shillings a week to the national average of ten. In their defence, George Loveless addressed the judge in eloquent and dignified manner:

> My lord, if we have violated any law, it was not done intentionally; we have injured no man's reputation, character, person, or property: we were uniting together to preserve ourselves, our wives and children from utter degradation and starvation.

Forty-one years later Loveless and his fellow victims were celebrated at a huge gathering at Briantspuddle, and a hymn was written specially for the occasion:

> They need no storied urn or bust
> Who once in yonder dungeon lay;
> The tyrant's fame is turned to dust,
> The felon's fame we sing this day.
>
> The life they lived to us imparts
> Strength in the fight with brutal wrong;
> We keep their memories in our hearts,
> And wreath their names in flowers of song.

But even with the overthrow of the more Draconian measures against working people, life remained harsh, wages remained low, and accommodation pitiful. In 1868 the Royal Commission on the Employment of Women

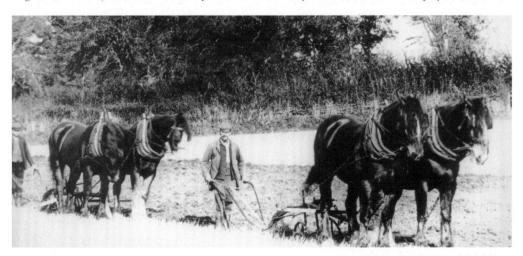

PLOUGHING, HIGHER KINGSTON

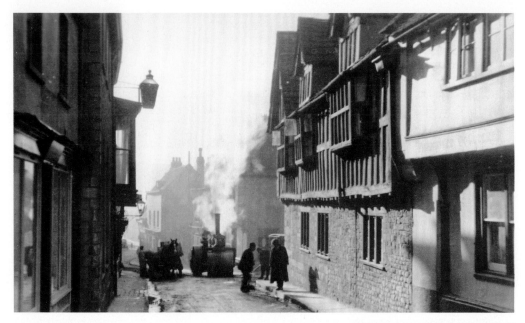

STEAM-ROLLER, SHERBORNE

and Children in Agriculture cited one example of a family of eight living in an outhouse built for cattle. An earlier census reported a single cottage divided into three which housed thirty-five people. Earlier enclosure acts had deprived farm labourers of their free grazing rights on the commons; those who were allowed allotments by their masters were strictly forbidden to work them on Sundays. And looming over the latter end of life was that great instrument of Victorian oppression, the workhouse.

This picture of grinding poverty and endemic misery is familiar to us from the works of Dorset's great chronicler, Thomas Hardy. His images of people pushed to the limits of physical endurance in their attempts to wring a living from their environment remain burnt into the mind of anyone who has read his novels. Hardy knew his native county as well as anybody, and devoted his life to recording and commemorating its landscape and its people. Most of his fiction is set back in time a little, but he did not live in the past, and was fully aware of the agents for change affecting contemporary life—the introduction of farm machinery, for instance, and the eclipse of local cottage industries such as button making by the factory production of the north.

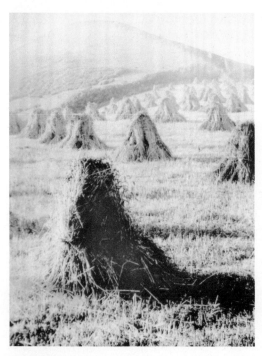

STOOKS

People were gradually quitting the villages and moving into the towns, leaving an eerily empty countryside behind them. Rider Haggard, who toured the county as part of his survey of agricultural England in 1901, reports on a lengthy journey during which he saw only four other vehicles: 'three of them were brewers' drays, and the fourth was a timber-drag'. The move to the towns was often a matter of economic necessity, but for a new generation, town life was more alluring than the traditional round of village existence. Hardy's poem, 'The Ruined Maid', rather roguishly contrasts town sophistication and country innocence:

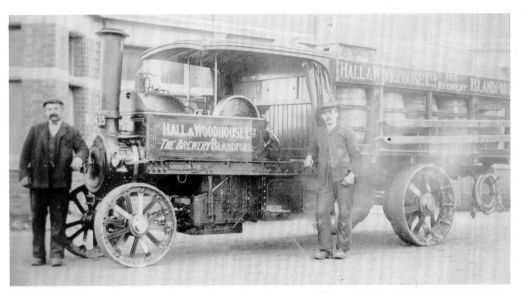

HALL & WOODHOUSE STEAM DRAY

'O 'Melia, my dear, this does everything crown!
Who could have supposed I should meet you in Town?
And when such fair garments, such prosperi-ty?'
'O didn't you know I'd been ruined?' said she.

—'You left us in tatters, without shoes or socks,
Tired of digging potatoes, and spudding up docks;
And now you've gay bracelets and bright feathers three!'—
'Yes: that's how we dress when we're ruined,' said she.

—'At home in the barton you said "thee" and "thou",
And "thik oon", and "theas oon", and "t'other"; but now
Your talking quite fits 'ee for high comapa-ny!'—
'Some polish is gained with one's ruin,' said she.

There were of course those for whom the Dorset dialect was not something to be scorned (Hardy was among them). It found its strongest champion in William Barnes, a figure much revered in his own day, as the many accounts of visits to him by eminent fellow-writers attest. But he was not the only poet to write in dialect. Sturminster Newton, Barnes's birthplace, was home to another dialect poet, Robert Young, who under the pen-name 'Rabin Hill' proved equally fluent and almost as prolific. However, by the time this 'Olde Dorset Songster' died in 1908, having spent all his ninety-seven years in his native parish, the dialect that he loved was in decline. Wilkinson Sherren, in *The Wessex of Romance*, ponders the inevitable erosion of the local speech and local traditions, brought about partly by education, partly by the opening up of Dorset to the influence of the wider world by the railways.

There's a tendency to look back fondly to the Golden Age of Steam, but there were many who resisted the extension of the railways network. Wordsworth is a famous example, fulminating against the violation of his beloved Lake District, which he himself had almost single-handedly turned into a tourist attraction. The Dorset coast was similarly ripe for the invasion of the Victorian holiday-maker, and after the sparsely populated views of isolated villages, it can be a pleasant change to turn to photographs of crowded beaches and esplanades. The Dorset coastal towns were of course already holiday resorts, but for a rather more refined clientele. Weymouth had led the way under the patronage of George III (see the monument raised to the sea-bathing monarch, p.87). Now the hordes of trippers needed to be catered for. 'Swanage devotes itself body and soul to a hearty multitude called by the townfolk "the steamer people"', remarks Sir Frederick Treves in his *Highways and Byways of Dorset*

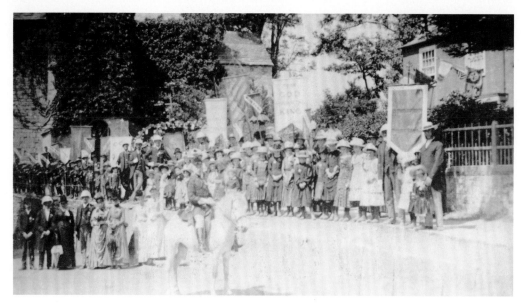

SANDFORD SCHOOL AT THE JUBILEE PROCESSION

(1906). Sir Frederick does his best to acknowledge that 'probably none in these islands deserve a holiday more thoroughly than do the "steamer people"', but points to the seemingly inevitable corollary of mass tourism.

Every available surface in this smugglers' haunt is carved with the names or initials of steamer people, while the ground is littered with their bottles, their egg-shells and their paper bags.

Smuggling by then was a thing of the past, but there were still those living whose memories went back to the days of dark nights with lanterns on the cliff tops. John Meade Falkner, whose unpublished family memoir provides glorious glimpses of a Dorset boyhood when '"Bournemouth" meant [only] an interminable tract of sand and heather and pines and wild rhododendrons', was just in touch with that lost world which inspired his famous novel *Moonfleet*.

But smuggling was not the only activity associated with the coastal waters. Fishermen feature widely in photographs of the period, mending their nets, putting out their boats, bringing home the catch. And at Portland, seafaring on an altogether different scale was serviced in the Royal Navy's dockyards. Portland, too, boasted a prison—and a quarry. The prisoners exercised an astonishing fascination over the makers of picture postcards, and I have included only a small sample. In addition to sending home postcards of what he hadn't been doing on his holiday, the Victorian tourist could also enjoy browsing through the fossil shops of Lyme Regis, supplied by an intrepid band of collectors who would scour the cliffs for finds. Finally, the shore could throw up rather more dramatic fare. As the village children chant in *Moonfleet*, 'Blow wind, rise storm, Ship ashore before morn.' Every storm was likely to claim its victims, and with the strong tides and terrifying under-tow of Chesil Beach, described by Falkner, (p.91), and such lethal snares as the Kimmeridge Ledges, stretches of the coast were notoriously dangerous. Among the first to reach any disaster spot would of course be the photographers; there are even more postcards of shipwrecks than there are of prisoners breaking stones.

In compiling the text for this book, I have tried to draw on a wide range of sources. Poets and novelists are not the only witnesses to the living past. Diarists and journalists give us the feel of life as it was lived day by day—a carriage accident in Weymouth, a Swanage visitor put upon by a none-too-honest local, a more peaceful boat trip to Durdle Door. Dr Buchanan reminds us that even once the move to the town had been made, conditions were likely to be appalling for the poorest, and I have also included a passage on the geology of the Isle of Purbeck and a vivid account of the Swanage quarrymen.

No book of this length could encompass all aspects of a county's life, but I hope the extracts I have chosen, along with the selection of photographs, will give an authentic flavour of Victorian and Edwardian Dorset.

Victorian &
Edwardian
Dorset

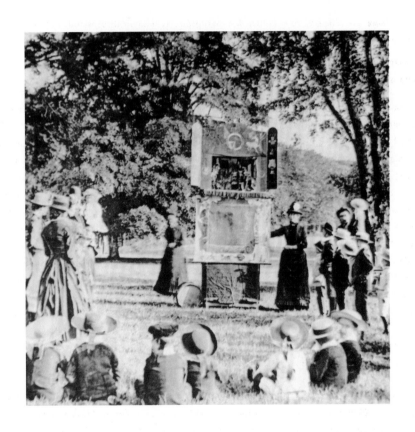

R. B. BROWN,

MANUFACTURER OF:

MARQUEES, TENTS, RICK CLOTHS, TARPAULINS AND SACKS,

DORCHESTER.

Rain and Rot-proof Covers for Wagons. Machines, Engines, Vans, Carts, &c. Cricket Marquees, Garden Tents, Game and Garden Netting, Sheep Shelters, &c.

Waterproof Garments, Riding and Driving Aprons. India-Rubber Door and Carriage Mats. Garden Hose, Horse Clothing, Loin Cloths, Nose-bags, Ropes, Binder Twine, &c.

MARQUEES, TENTS, FLAGS, RICK CLOTHS & TARPAULINS ON HIRE.

PRICES ON APPLICATION.

R. B. BROWN, Tent & Rick Cloth Manufactory, DORCHESTER.

THE BRANKSEA ISLAND COMPANY, LIMITED,

(LATE BRANKSEA POTTERY), MANUFACTURERS OF

BEST SALT GLAZED STONEWARE DRAIN PIPES, SYPHONS, GULLIES,

TRAPS, INVERTS, &c., &c.

Terra Cotta Chimney Pots & Chimney Cores, Fire Bricks, Garden Edgings, &c., &c.

PRICE LISTS ON APPLICATION. *VESSELS LOADED ALONGSIDE.*

WORKS, BRANKSEA, POOLE, DORSET.

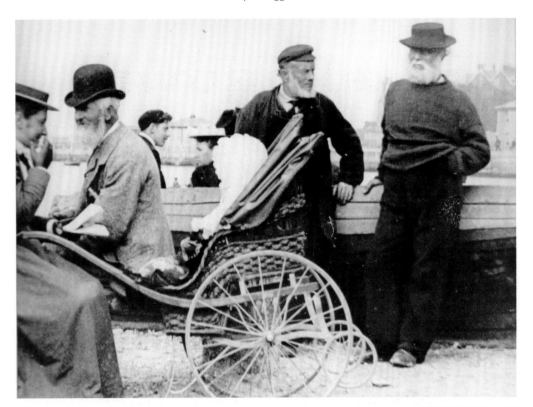

SWANAGE BEACH

MOVE TO SWANAGE

Dorchester was considered to be an exceptionally healthy place. In Doctor Abernethy's apophthegm it was a town 'where a physician could neither die nor live', but my mother's anxieties suggested that water-meadows were too close, that there was so much foliage and so many gardens that vegetable decay might be prejudicial to 'delicate' children. Sea-side 'holidays' seemed likely to be beneficial and so we were taken away to Swanage. Swanage was an ideal spot, unspoilt by Bournemouth, for Bournemouth was not yet in existence, revelling in the full breezes of the Channel, the home of rugged fisher-men and more rugged quarry-men.

There was a fine open sea-front with smooth and gently-falling sands, the beach was strewn with wonderfully beautiful shells, the background was formed by sandy cliffs neither too high nor too steep to present any dangers, and the country round was famous for its wild flowers. There were no 'trippers', there were no hotels to oppress, lodgings were very few and the only access was a coach which once a day covered the 12 miles of sand and pine lying between unknown Swanage and unknown Wareham. Three servants came with us from Dorchester, and we occupied the whole of a roomy old house which stood a 100 yards back from the sea. It was then called Belleview but had once been an inn, and the fittings of the 'bar' still remained in a side-room.

'Bournemouth' meant to us children, and I suspect for every one else at that time, an interminable tract of sand and heather and pines and wild rhododendrons. It was all an ideal play-ground. The pines grew close together, there was an air of sombre mystery underneath them and above they would keep out rain for quite a long time. The floor of pine-needles was always dry and we could sit about at our ease, and in the thick clumps of rhododendrons could be found secret-passages, and covered bowers and smugglers' caves.

Never could children have had a more ideal guide and playmate than my father. He would take pains to explain *everything*, he had an answer for endless questions, he would carry a little lunch-basket from Swanage with cold meat and hard-boiled eggs and add to it as we went along buns and sponge-cakes and a bottle of milk. He knew *all* about flowers and *all* about birds and *all* about weasels and hedgehogs and badgers and snakes and glow-worms. When the milk was gone he could find a spring of drinking-water, and a little lower down in the stream

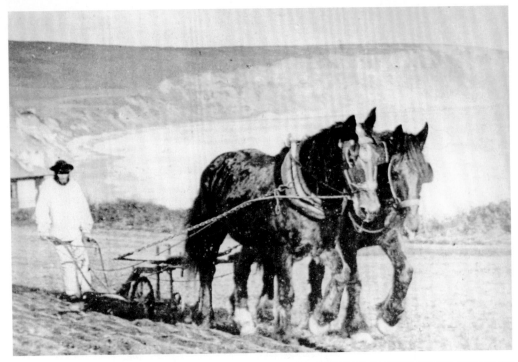

PLOUGHING ON THE CLIFFS, SWANAGE

could be picked watercress to take back in the empty basket to Swanage.

If they were halcyon days to us I think that they were halcyon days to my father also. It was a moment of expansion for him, a return to the 'Country' which was always so very close to his heart. Never was there a more thorough countryman than he. He looked upon little Dorchester and little Weymouth as centres of seething activity, and was never tired of a favourite maxim 'God made the Country and man made the Town'. I shall find occasion to return to this theme of the 'Country' later on but for the moment we are at Swanage.

DEPOT GATES, DORCHESTER

We were out of doors from morning to night. I dare say that we took walks longer than my mother would have approved, longer perhaps than might have been considered advisable at our age, but I never remember either of us being tired. Perhaps the thing which we most enjoyed was to climb the great downs which form the background of Swanage. On them lay a land of pure delight, close sward, thyme and hare-bells, little painted snail shells, countless butterflies and bees. Such things impressed themselves upon us as children and became an inalienable asset of later life. Nine-Barrow Down (what a name of incantation!) could never fade from memory. I remember being there one year at the time of orchids. We filled baskets and handkerchiefs with bee-orchises which were so uncannily like bees that we were half afraid of them, and my father found the man-orchis and the butterfly-orchis and more, I dare say, besides. He was specially fond of orchids knowing them well from Wiltshire and afterwards we found the bee-orchis sparsely near

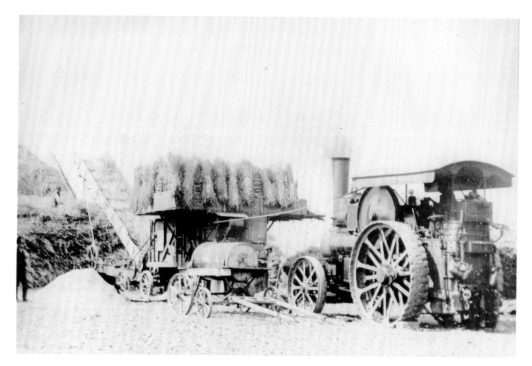

STEAM ENGINES

Dorchester and in greater numbers at Portland but never so many as grew near Swanage.

There was too a mysterious fascination in the nearly deserted purbeck-marble quarries in the background and in the sheer cliffs and sea-caverns which fronted the Channel. It is a terrible cliff line because the face rises straight out of the sea and at the base there is such deep water that a ship may drive on without anything to warn her until she is shattered on a wall that no-one can climb. Perhaps it was from such a place that originated the old Dorset proverb 'He that will not be ruled by the rudder will be ruled by the rock'. The coast has been exploited since our time to please 'trippers' with passages of easy access and Biblical texts neatly carved on smooth-planed rocks, but there was nothing of all this then, and it was something of an adventure to clamber down to Tillywhym, with its long-disused sea-quarries and a reputed 'underground passage' to Corfe Castle.

John Meade Falkner

STEAM-PLOUGHS AND FOSSILS

I remember once that he [my father] took me and May to see a steam-plough working in the great corn-fields of the Duchy of Cornwall. It was an invention which was beginning to attract much attention, and it interested us greatly. On this occasion my father took me to task more sharply than I ever remember his doing at any other time. The plough had been stopped for some adjustment and a red flag had been stuck up in the field to show that men were at work upon it and that the engine must not be started. I took up the flag and began playing with it, and the man-in-charge spoke strongly to my father saying that if he brought children to see machinery he was responsible for keeping them in order. My father said that unless we were more thoughtful he should not take us out again, and I did not forget the admonition. In his walks with us at Dorchester he took much interest in turning out fossils, especially ammonites and belemnites which are common in the neighbourhood.

He was himself much given to the study of geology and fossils for which Weymouth and its surrounding cliffs offer great opportunity. At Weymouth he had a great geological friend of the name of Damen who had written books on the subject and attained something more than a local reputation. My father's happiest hunting ground was the cuttings of new railways which were being everywhere constructed. He made more than one collection

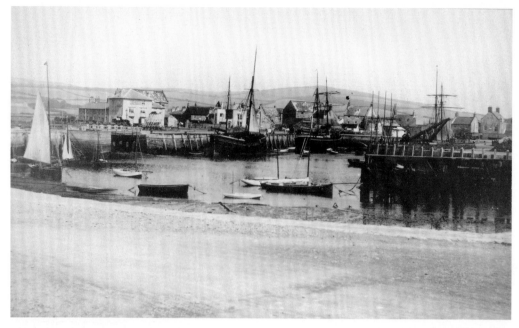

HARBOUR, WEST BAY

of fossils and was assured by expert people that he had in them examples of considerable value. His specimens had been got together in Wiltshire, but my father's inveterate dislike to take trouble on his own account, and his policy of laisser aller never allowed him to turn his geological collections to practical account.

John Meade Falkner

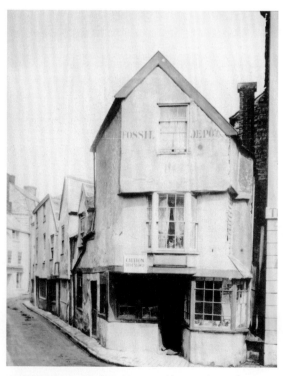

FOSSIL SHOP, LYME REGIS

BY BOAT TO DURDLE DOOR

26 September 1874: After luncheon we all went down to W. Lulworth and went some walking, others by boat to Durdle Door—where we had tea—it was a perfect afternoon. Agnes, Aunt Teresa and I went in one boat with old Vye who pulled us along very steadily—Aunt Teresa was most active and delighted in the fishing—it was a very long time before the kettle boiled it was so exposed, the tea was most successful when it did boil—we were prevented seeing the cave at Durdle Door—owing to the High tide the cave was full of water—it was most exquisite rowing home, the moon was up, shining on the boats and the weather quite warm. Edith, Freddie, Emmy and I were rowed by little William and Henry and Johnny alternately—we got home for dinner about 8.30.

Constance Weld

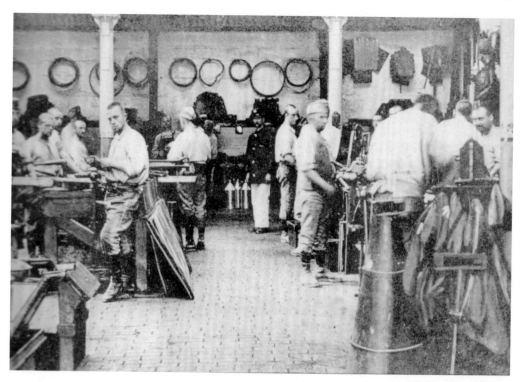

PRISON WORKSHOP, PORTLAND

AT THE RAILWAY STATION, UPWAY

'There is not much that I can do,
 For I've no money that's quite my own!'
 Spoke up the pitying child—
A little boy with a violin
At the station before the train came in,—
'But I can play my fiddle to you,
And a nice one 'tis, and good in tone!'

 The man in the handcuffs smiled;
The constable looked, and he smiled, too,
 As the fiddle began to twang;
And the man in the handcuffs suddenly sang
 With grimful glee:
 'This life so free
 Is the thing for me!'
And the constable smiled, and said no word,
As if unconscious of what he heard;
And so they went on till the train came in—
The convict, and boy with the violin.

Thomas Hardy

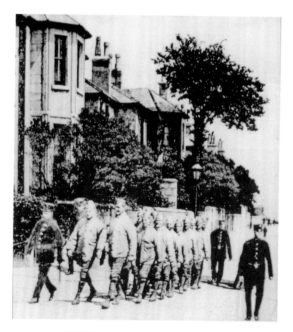

PRISONERS RETURNING FROM WORK,
PORTLAND

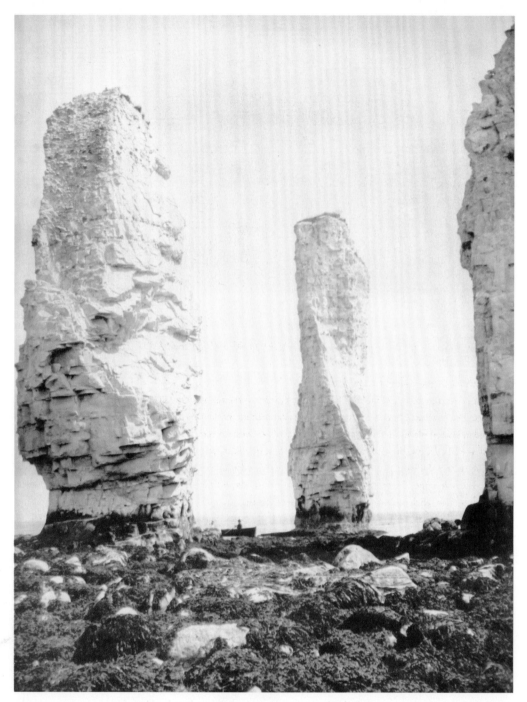

OLD HARRY AND WIFE, STUDLAND

A UNIQUE COAST (THE ISLE OF PURBECK)

Every hard rock makes its headland, and every soft band its bay. But the Portland Stone and Lower Purbeck Limestones more especially give a craggy aspect to the scenery wherever they are intersected by the coast-line. Observe for example the Durlston and Winspit cliffs, the crags crowning the precipitous lower slopes of St Albans Head, Hounstout, Swyre Head and Gad Cliff, and the ruined rampart of vertical limestones

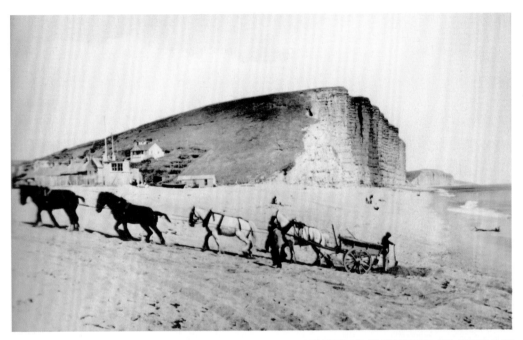

HAULING SHINGLE FROM THE BEACH, WEST BAY

behind which lie the coves at Lulworth.

In these coves may be found the most perfect illustration of the action of the sea upon inclined strata of unequal hardness. The rampart alluded to, formed by Portland Stone backed by Lower Purbeck Limestones, has been breached in several places, and in fact, so far as regards its western end, survives only in isolated rocks, known as the Bull, the Blind Cow, the Cow and the Calf. The first step in its demolition can be traced in Stair Hole, 200 or 300 yards west of Lulworth Cove. Here the sea having bored a hole in it has gained access to the Wealden strata behind. The soft Upper Purbeck strata and the Wealden sands and clays are being rapidly scoured out, leaving a large oval hollow; enclosed seawards by a wall of limestone.

The next stage is shown in Lulworth Cove. Here the limestone wall has been fairly breached, and the hollow behind has been enlarged into a slightly oval but beautifully symmetrical natural harbour, about 450 yards in its longer diameter. The oval shape is due to the fact that the sea has reached the chalk on the northern side, and that its progress has been checked; the enlargement of the harbour now takes place chiefly on the eastern and western sides.

A still further stage is illustrated in Worbarrow and Mupe Bays. Here the 'wall' has perished for a distance of a mile and a half, and the chalk forms an inner cliff for a slightly less distance.

Similar effects have been produced in Man o' War Cove, where the rock which gives the name is formed by a remnant of the 'wall', and at Durdle Door where the sea has pierced the 'wall' in the archway of that name. In all cases the chalk forms the first serious obstacle to the waves after the Purbeck Limestones have been passed.

The chalk itself, however, yields in time. At Bats Head and Arish Mell the waves have bored caves through the vertical and greatly hardened beds. At the Foreland where the chalk is less disturbed and not so hard, the waste is more rapid. The cliff is traversed by nearly vertical joints which cause it to break away into roughly rectangular masses. Several great columns of chalk, one of which is known as Old Harry, stand detached from the cliff, and a much larger mass now forming the promontory of the Foreland, and connected with the mainland by an extremely narrow neck, will before long be disconnected. One of the pinnacles known as Old Harry's Wife was destroyed by the sea in 1896.

Aubrey Strahan

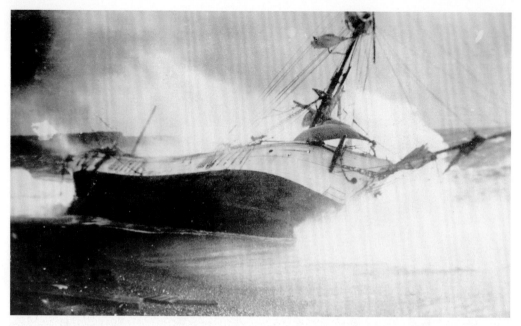

THE *PATRIA* WRECKED, PORTLAND

THE CRUEL SEA

As he went a sudden blast of air came over the hill. . . and spoilt the previous quiet of the scene. The wind had already shifted violently, and now smelt of the sea.

The harbour road soon began to justify its name. A gap appeared in the rampart of hills which shut out the sea, and on the left of the opening rose a vertical cliff, coloured a burning orange by the sunlight, the companion cliff on the right being livid in shade. Between these cliffs, like the Libyan bay which sheltered the shipwrecked Trojans, was a little haven, seemingly a beginning made by Nature herself of a perfect harbour, which appeared to the passer-by as only requiring a little human industry to finish it and make it famous, the ground on each side as far back as the daisied slopes that bounded the interior valley being a mere layer of blown sand. But the Port Bredy burgesses a mile inland had, in the course of ten centuries, responded many times to that mute appeal, with the result that the tides had invariably choked up their works with sand and shingle as soon as completed. There were but few houses here: a rough pier, a few boats, some stores, an inn, a residence or two, a ketch unloading in the harbour, were the chief features of the settlement. On the open ground by the shore stood his wife's pony-carriage, empty, the boy in attendance holding the horse.

When Barnet drew nearer, he saw an indigo-coloured spot moving swiftly along beneath the radiant base of the eastern cliff; which proved to be a man in a jersey, running with all his might. He held up his hand to Barnet, as it seemed, and they approached each other. The man was local, but a stranger to him.

'What is it, my man?' said Barnet.

'A terrible calamity!' the boatman hastily explained. Two ladies had been capsized in a boat—they were Mrs Downe and Mrs Barnet of the old town; they had driven down there that afternoon—they had alighted, and it was so fine, that, after walking about a little while, they had been tempted to go out for a short sail round the cliff. Just as they were putting in to the shore, the wind shifted with a sudden gust, the boat listed over, and it was thought they were both drowned. How it could have happened was beyond his mind to fathom, for John Green knew how to sail a boat as well as any man there.

'Which is the way to the place?' said Barnet.

It was just round the cliff.

'Run to the carriage and tell the boy to bring it to the place as soon as you can. Then go to the Harbour Inn and tell them to ride to town for a doctor. Have they been got out of the water?'

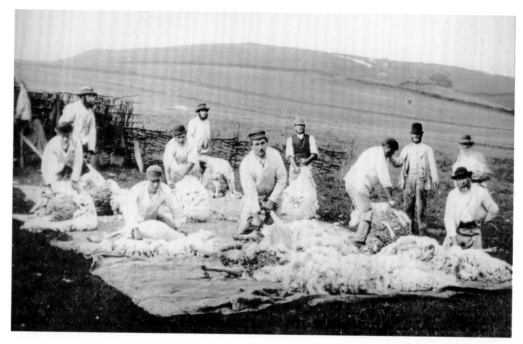

SHEARING ON THE DOWNS

'One lady has.'

'Which?'

'Mrs Barnet. Mrs Downe, it is feared, has fleeted out to sea.'

Barnet ran on to that part of the shore which the cliff had hitherto obscured from his view, and there discerned, a long way ahead, a group of fishermen standing. As soon as he came up one or two recognized him, and, not liking to meet his eye, turned aside with misgiving. He went amidst them and saw a small sailing-boat lying draggled at the water's edge; and, on the sloping shingle beside it, a soaked and sandy woman's form in the velvet dress and yellow gloves of his wife.

Thomas Hardy

BRIDPORT—A VERITABLE TOWN

The shepherd on the east hill could shout out lambing intelligence to the shepherd on the west hill, over the intervening town chimneys, without great inconvenience to his voice, so nearly did the steep pastures encroach upon the burghers' backyards. And at night it was possible to stand in the very midst of the town and hear from their native paddocks on the lower levels of the greensward the mild lowing of the farmer's heifers, and the profound, warm blowings of breath in which those creatures indulge. But the community which had jammed itself in the valley thus flanked formed a veritable town, with a real mayor and corporation, and a staple manufacture.

Thomas Hardy

BLACKFACE SHEEP

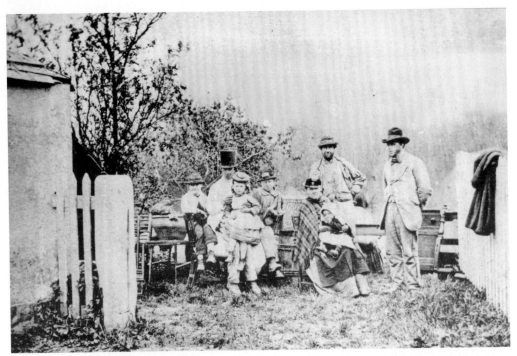

EVICTED FAMILY OF FARM LABOURERS

AGRICULTURAL DEPRESSION

At Turnworth we were most hospitably received by Mr Tory. This gentleman belongs to the old school of yeoman farmers, of whom he is a perfect type. As I looked at him, surrounded by his stalwart sons and handsome daughters, I could not help wondering whether in another score of years rural England would have many such families to show. I trust that it may be so, for surely such as he and his are, or have been, the very backbone of the nation. Including his brother, who was also present, those of his family who were gathered round his table,

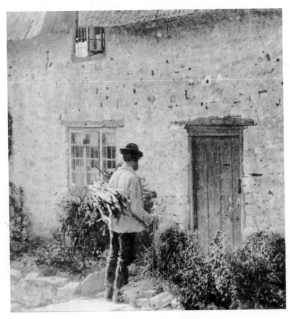

'FATHER COME HWOME'

farmed between them no fewer than 6,000 acres of Dorset land, and have so farmed for many years. Few can be better acquainted with the local conditions, and it is therefore with the more regret that I have to record their views of the agricultural outlook.

Mr Tory, jun., the valuer, said he could see nothing ahead but ruin, and that the only hope of salvation lay in small holdings, whereas his uncle—note the contrast of opinion between the old man and the young—thought that the land must be divided into great farms and worked by capitalists. They all believed the outlook to be as bad as possible, and one of them, who had been abroad, added that Dorsetshire farming must fall to the level of that practised in the Colonies. It would be a case of 'peasant proprietors or ranches', the small holder feeding himself and no more, and the big man breeding herds of half-wild cattle.

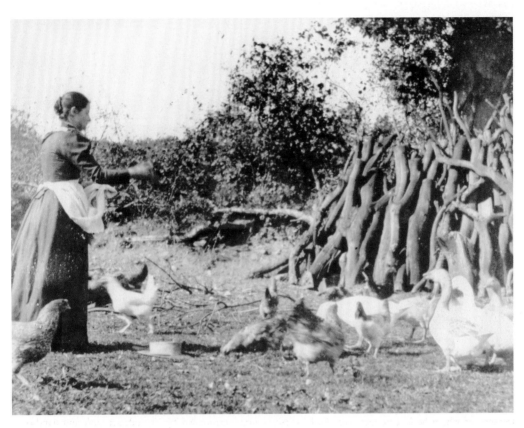

WOMAN IN FARMYARD

Of labour their tale was the same as that which I had heard in so many places, only, perhaps, worse. They said it was a very great difficulty, and they could not guess what the future was to be; moreover, its quality was bad. They supposed that the farmers must do the work themselves, and that meant misery for everybody. Mr J. Tory added that not one in fifty of the young fellows would stop upon the land, so the only thing to do was to lay it down to grass. Some people could find no hands to milk. In many cases the state of the cottages was very bad. How could a girl who had been in service be expected to live in a hovel when she married? Of course the result was that she and her husband went away. Without labour the land was worthless, and without proper cottages there could be no labour. But, in truth, I am weary of repeating that melancholy story.

H. Rider Haggard

PIDDLETRENTHIDE

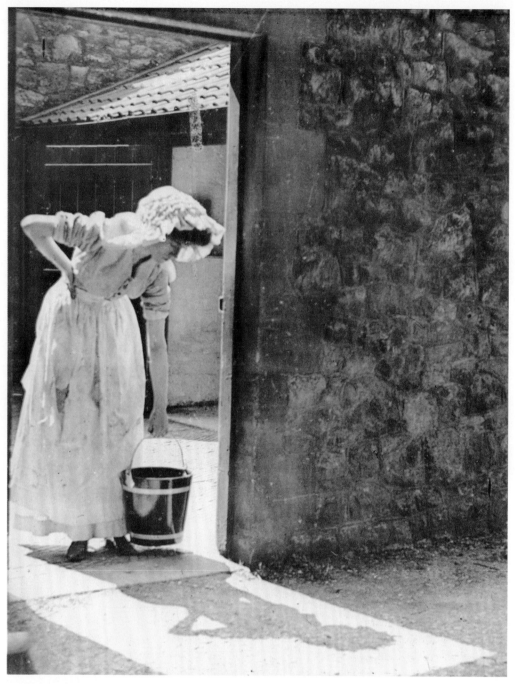

GIRL WITH PAIL

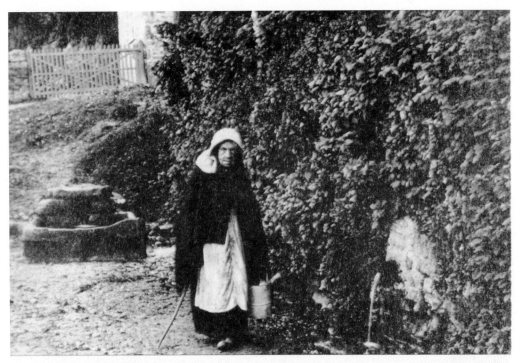

VILLAGE WATER TROUGH, STOKE ABBOTT

STURMI'STER COMMON IN ZUMMER TIME

[A poor woman's lament at the labour of fetching water from Woolhouse brook.]

I'm tired out, a'mos' to dath!
Can hardly speäk, vor want o' brath,
A-bringen up vrom Oolhouse brook
Theäse drap o' warter vor to cook.

Our common land do stan' ser high,
That pits an' ditches all be dry;
What we do zuffer none can tell!
I only wish we'd got a well.
Vor when our pit's vull up to brink,
It idden vit vor Christèns' drink;
'Tis all alive wi 'twoads an' vrogs,
An' only good vor cows and hogs.

Our Sal went out woone darkzome night
To vill the kittle 'vore 'twer light;
An' as we all at breakvast zot,
Whatever do'ee think we got?

We drink'd a dish o' tay all roun',
An' then, I'll tell 'ee what we voun'?
We coudden git the warter out
Vrom our girt kittle's zmutry spout;

But hangen vrom his steämèn lip
Zome slimly krissly bwones did slip.
The zight o'it took away our brath,
To think we'd bweil'd a vrog to dath.

Our Jack turned pale; took up his hat
An' went outzide to "shoot the cat."
"'Tis zad," I zed, "the teaäe you tell;
How streänge you do not zink a well!

Wishèn, yer know, oon't do the thing,
Zoo zet to work and vind a spring.
The bees combine to bring hwome honey,
Zoo club all roun' and gat the money

Then work away wi' might and maïn
And you'll the priceless trasure gaïn;
And then you'll hear yer kittle zing
Wi' purest warter vrom the spring."

Robert Young (Rabin Hill)

WEST WALK, DORCHESTER

FIRST SIGHT OF CASTERBRIDGE (DORCHESTER)

It was on a Friday evening; near the middle of September, and just before dusk, that they reached the summit of a hill within a mile of the place they sought. There were high-banked hedges to the coach-road here, and they mounted upon the green turf within, and sat down. The spot commanded a full view of the town and its environs.

'What an old-fashioned place it seems to be!' said Elizabeth-Jane, while her silent mother mused on other things than topography. 'It is huddled all together; and it is shut in by a square wall of trees, like a plot of garden ground by a box-edging.'

Its squareness was, indeed, the characteristic which most struck the eye in this antiquated borough, the borough of Casterbridge—at that time, recent as it was, untouched by the faintest sprinkle of modernism. It was compact as a box of dominoes. It had no suburbs—in the ordinary sense. Country and town met at a mathematical line.

To birds of the more soaring kind Casterbridge must have appeared on this fine evening as a mosaic-work of subdued reds, browns, greys, and crystals, held together by a rectangular frame of deep green. To the level eye of humanity it stood as an indistinct mass behind a dense stockade of limes and chestnuts, set in the midst of miles of rotund down and concave field. The mass became gradually dissected by the vision into towers, gables, chimneys, and casements, the highest glazings shining bleared and bloodshot with the coppery fire they caught from the belt of sunlit cloud in the west.

From the centre of each side of this tree-bound square ran avenues east, west, and south into the wide expanse of cornland and coomb to the distance of a mile or so. It was by one of these avenues that the pedestrians were about to enter.

Having sufficiently rested they proceeded on their way at evenfall. The dense trees of the avenue rendered the road dark as a tunnel, though the open land on each side was still under a faint daylight; in other words, they passed down a midnight between two gloamings. The features of the town had a keen interest for Elizabeth's mother, now that the human side came to the fore. As soon as they had wandered about they could see that the stockade of gnarled trees which framed in Casterbridge was itself an avenue, standing on a low green bank or escarpment, with a ditch yet visible without. Within the avenue and bank was a wall more or less discontinuous, and within the wall were packed the abodes of the burghers.

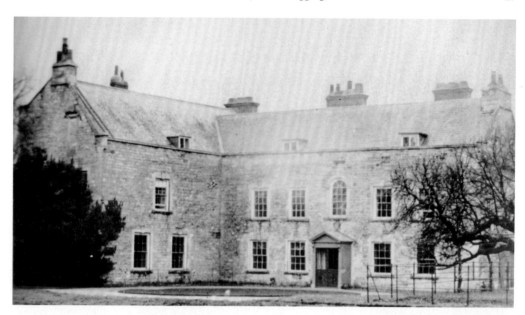

COLLITON HOUSE, DORCHESTER

Though the two women did not know it these external features were but the ancient defences of the town, planted as a promenade.

The lamplights now glimmered through the engirdling trees, conveying a sense of great snugness and comfort inside, and rendering at the same time the unlighted country without strangely solitary and vacant in aspect, considering its nearness to life. The difference between burgh and champaign was increased, too, by sounds which now reached them above others—the notes of a brass band. The travellers returned into the High Street, where there were timber houses with overhanging stories, whose small-paned lattices were screened by dimity curtains on a drawing-string, and under whose barge-boards old cobwebs waved in the breeze. There were houses of brick-nogging, which derived their chief support from those adjoining. There were slate roofs patched with tiles, and tile roofs patched with slate, with occasionally a roof of thatch.

The agricultural and pastoral character of the people upon whom the town depended for its existence was shown by the class of objects displayed in the shop windows. Scythes, reaphooks, sheep-shears, bill-hooks, spades, mattocks, and hoes at the ironmonger's; bee-hives, butter-firkins, churns, milking stools and pails, hay-rakes, field-flagons, and seed-lips at the cooper's; cart-ropes and plough-harness at the saddler's; carts, wheel-barrows, and mill-gear at the wheelwright's and machinist's; horse-embrocations at the chemist's; at the glover's and leather-cutter's, hedging-gloves, thatchers' knee-caps, ploughmen's leggings, villagers' pattens and clogs.

They came to a grizzled church, whose massive square tower rose unbroken into the darkening sky, the lower parts being illuminated by the nearest lamps sufficiently to show how completely the mortar from the joints of the stonework had been nibbled out by time and weather, which had planted in the crevices thus made

EAST STREET, BLANDFORD

THE GIANT, CERNE ABBAS

little tufts of stone-crop and grass almost as far up as the very battlements. From this tower the clock struck eight, and thereupon a bell began to toll with a peremptory clang. The curfew was still rung in Casterbridge, and it was utilized by the inhabitants as a signal for shutting their shops. No sooner did the deep notes of the bell throb between the house-fronts than a clatter of shutters arose through the whole length of the High Street. In a few minutes business at Casterbridge was ended for the day.

Other clocks struck eight from time to time—one gloomily from the gaol, another from the gable of an almshouse, with a preparative creak of machinery, more audible than the note of the bell; a row of tall, varnished case-clocks from the interior of a clock-maker's shop joined in one after another just as the shutters were enclosing them, like a row of actors delivering their final speeches before the fall of the curtain; then chimes were heard stammering out the Sicilian Mariners' Hymn, so that chronologists of the advanced school were appreciably on their way to the next hour before the whole business of the old one was satisfactorily wound up.

Thomas Hardy

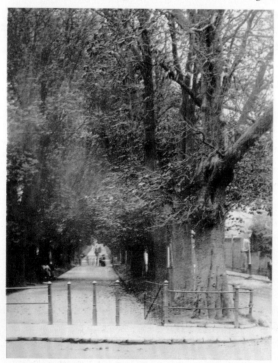

SOUTH WALK, DORCHESTER

SUPERSTITION AND IGNORANCE

Until a very recent date, there existed blackwaters in the land of Wessex untouched by the advance of progressive ideas, which, in more populous districts, had done much to remove superstition and ignorance. This lack of knowledge was often conspicuous in the case of illness. There were two reasons why poor folk did not trouble the village

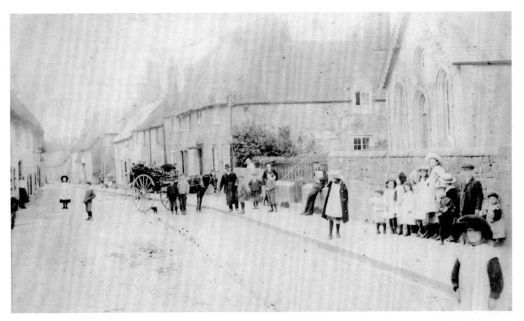

ST JAMES STREET, SHAFTESBURY

doctor in any sickness save the gravest—because of the obvious expense entailed, and on account of a profound belief in traditional nostrums, either suggested by a neighbour, or sometimes devised by their own mother wit. Adders' bites were treated with the boiled fat of the reptile that had caused the injury, and warts were supposed to disappear with the decay of a piece of meat buried in the ground for that purpose. Persons afflicted with scrofula often ignored the orthodox channels through which healing could be obtained, preferring to visit a 'cunning man', one of whom held an annual levee known as 'Toad Fair' in the neighbourhood of Stalbridge. There he sold to the large throngs gathered round him legs torn from living frogs, which, if worn next the skin in a bag, he said, cured the above-named disease. A farmer who was known to an incumbent of a village near Shaftesbury suffered much as an infant, on one occasion underwent a trying ordeal. In obedience to a peculiar myth the nurse undressed the babe one morning at sunrise, and conveying him to a maiden ash tree split for the purpose, drew his naked body through the prongs; these were then bound up, and if adhesion between the severed parts followed, it was thought his affliction would thereby be removed. One of the most remarkable remedies on record sprang from the fertile brain of an old dame, who once complained to a visitor of internal pain. According to her diagnosis, she had felt her 'lights' rising in her throat, and in order to prevent them from wandering, she had swallowed a good charge of shot—'to keep 'em down' as she explained. Another woman who suffered from sciatica was advised to thread seven snails on a string and hang them before the fire, and as they burnt into ashes a cure would be effected. Most of these remedies are traditional, the chief healing ingredient in them being faith.

Wilkinson Sherren

THE DORSET LABOURER

The term a Dorset labourer, has frequently been used as an opprobrious epithet, and a synonym for unintelligent apathy. There he is, a speck of life against the dull earth he is tilling, warped and stained by labour, his speech unready, his gait slow, and his intellectual processes tardy. Reverence, however, not unmingled with wonder should enter into the contemplation of him—reverence for his humanity, and wonder at his characteristics. He may be poor and unenlightened, yet the Wessex peasant is lineally descended from a noble ancestry. Principally Celtic in origin, he is a survivor of the Saxon occupation, his very dialect embalming words of the old dead tongue, his superstitions eloquent of an inbred paganism which the Christian ages have not eradicated. Indeed, were it possible to develop and express the impressions latent in his brain, the past ages would glow into actuality

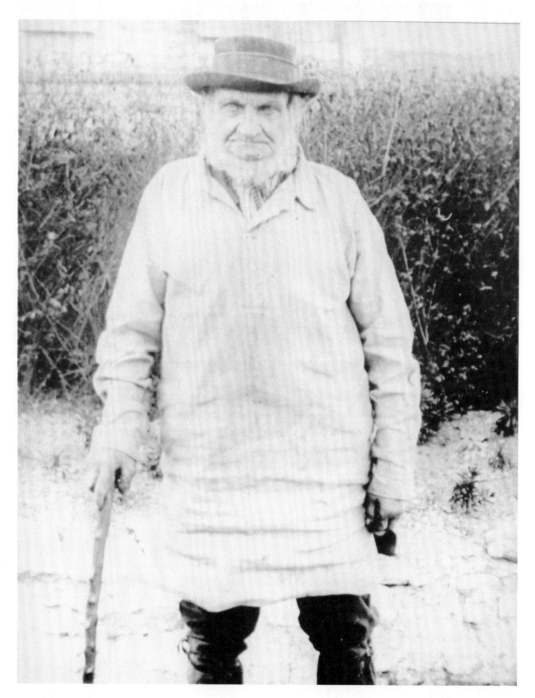

'STAFFORD DICK'

like renewed embers. Even the shadow of those fierce marauders, the Danes, was projected across the gulf of time into the nineteenth century, for until within recent years, there existed a vague tradition among the folk around Wool concerning certain red-haired savages who burnt and slew without mercy, a unique instance of the survival of pre-natal impressions.

Wilkinson Sherren

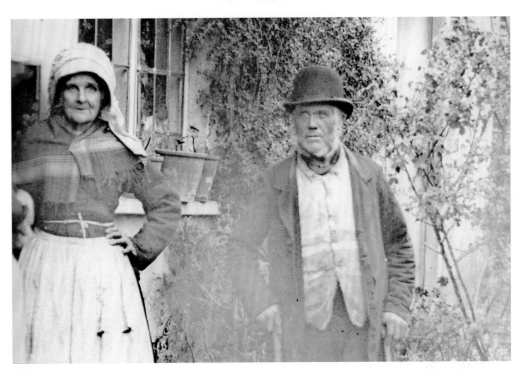

VILLAGERS, NETHERBURY

HANGMAN'S COTTAGE

At this date, and for several years after, there was a hangman to almost every jail. Gertrude found, on inquiry, that the Casterbridge official dwelt in a lonely cottage by a deep slow river flowing under the cliff on which the prison buildings were situate—the stream being the self-same one, though she did not know it, which watered the Stickleford and Holmstoke meads lower down in its course.

Having changed her dress, and before she had eaten or drunk—for she could not take her ease till she had ascertained some particulars—Gertrude pursued her way by a path along the water-side to the cottage indicated. Passing thus the outskirts of the jail, she discerned on the level roof over the gateway three rectangular lines against the sky, where the specks had been moving in her distant view; she recognized what the erection was, and passed quickly on. Another hundred yards brought her to the executioner's house, which a boy pointed . out. It stood close to the same stream, and was hard by a weir, the waters of which emitted a steady roar.

While she stood hesitating the door opened, and an old man came forth shading a candle with one hand. Locking the door on the outside, he turned to a flight of wooden steps fixed against the end of the cottage, and began to ascend them, this being evidently the staircase to his bedroom. Gertrude hastened forward, but by the time she reached the

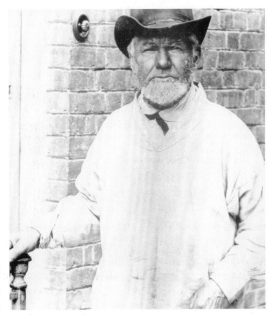

MAN IN SMOCK

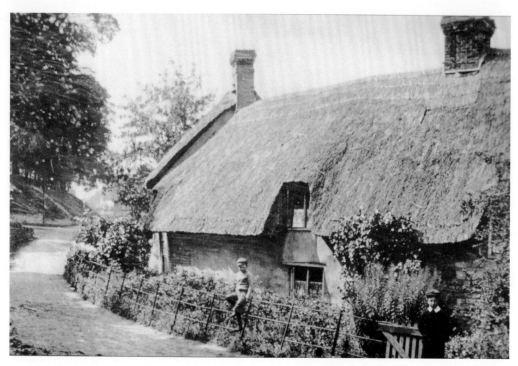

HANGMAN'S COTTAGE, DORCHESTER

foot of the ladder he was at the top. She called to him loudly enough to be heard above the roar of the weir; he looked down and said, 'What d'ye want here?'

'To speak to you a minute.'

The candle-light, such as it was, fell upon her imploring, pale, upturned face, and Davies (as the hangman was called) backed down the ladder. 'I was just going to bed,' he said; '"Early to bed and early to rise", but I don't mind stopping a minute for such a one as you. Come into house.' He reopened the door, and preceded her to the room within.

The implements of his daily work, which was that of a jobbing gardener, stood in a corner, and seeing probably that she looked rural, he said, 'If you want me to undertake country work I can't come, for I never leave Casterbridge for gentle nor simple—not I. My real calling is officer of justice,' he added formally.

'Yes, yes! That's it. Tomorrow!'

'Ah! I thought so. Well, what's the matter about that? 'Tis no use to come here about the knot—folks do come continually, but I tell 'em one knot is as merciful as another if ye keep it under the ear. Is the unfortunate man a relation; or, I should say, perhaps' (looking at her dress) 'a person who's been in your employ?'

'No. What time is the execution?'

'The same as usual—twelve o'clock, or as soon after as the London mail-coach gets in. We always wait for that, in case of a reprieve.'

'O—a reprieve—I hope not!' she said involuntarily.

'Well—hee, hee!—as a matter of business, so do I! But still, if ever a young fellow deserved to be let off; this one does; only just turned eighteen, and only present by chance when the rick was fired. Howsomever, there's not much risk of it, as they are obliged to make an example of him, there having been so much destruction of property that way lately'

'I mean,' she explained, 'that I want to touch him for a charm, a cure of an affliction, by the advice of a man who has proved the virtue of the remedy.'

'O yes, miss! Now I understand. I've had such people come in past years. But it didn't strike me that you looked of a sort to require blood-turning. What's the complaint? The wrong kind for this, I'll be bound.'

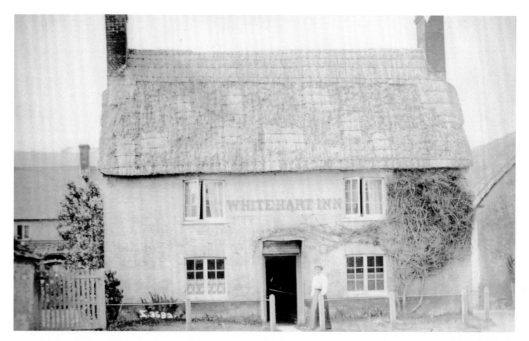

THE WHITE HART INN, SHROTON

'My arm.' She reluctantly showed the withered skin.

'Ah!—'tis all a-scram!' said the hangman, examining it.

'Yes,' said she.

'Well,' he continued, with interest, 'that *is* the class o' subject, I'm bound to admit! I like the look of the place; it is truly as suitable for the cure as any I ever saw. 'Twas a knowing man that sent 'ee, whoever he was.'

'You can contrive for me all that's necessary?' she said breathlessly.

'You should really have gone to the governor of the jail, and your doctor with 'ee, and given your name and address—that's how it used to be done, if I recollect. Still, perhaps, I can manage it for a trifling fee.'

'O, thank you! I would rather do it this way, as I should like it kept private.'

'Lover not to know, eh?'

'No—husband.'

'Aha! Very well. I'll get 'ee a touch of the corpse.'

'Where is it now?' she said, shuddering.

'It?—*he*, you mean; he's living yet. Just inside that little small winder up there in the glum.' He signified the jail on the cliff above.

She thought of her husband and her friends. 'Yes, of course,' she said; 'and how am I to proceed?'

He took her to the door. 'Now, do you be waiting at the little wicket in the wall, that you'll find up there in the lane, not later than one o'clock. I will open it from the inside, as I shan't come home to dinner till he's cut down. Good night. Be punctual; and if you don't want anybody to know 'ee, wear a veil. Ah—once I had such a daughter as you!'

She went away, and climbed the path above, to assure herself that she would be able to find the wicket next day. Its outline was soon visible to her—a narrow opening in the outer wall of the prison precincts. The steep was so great that, having reached the wicket, she stopped a moment to breathe; and, looking back upon the water-side cot, saw the hangman again ascending his outdoor staircase. He entered the loft or chamber to which it led, and in a few minutes extinguished his light.

The town clock stuck ten, and she returned to the White Hart as she had come.

Thomas Hardy

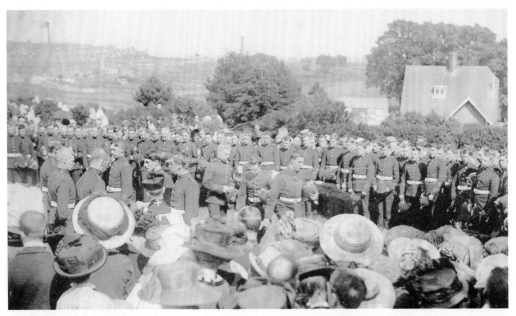

MILITARY FUNERAL, WEYMOUTH

DEATH OF A BEADLE

John Knight of Cliff Cottage aged 81: With him is closed a chapter in the history of the village: for years he performed with the utmost punctuality the duties of beadle in the church, and on the civic side he will be remembered as the one who from year to year summoned the members of the Court Leet as the ever recurring audit day came round. This court is now gone, and the beadleship as he knew it with its distinctive paraphernalia and wand of office, is no more.

Burton Bradstock Parish Magazine, 11 September 1904

DEATH

Death had its own peculiar rites, and these have obtained till a recent period. In Lulworth the dead were occasionally laid out with a penny in one hand and a little wooden hammer in the other. When a native lay a-dying, it was believed he would pass away 'easier' if the doors and windows were allowed to remain open, the passage into the other world being still further smoothed when the pillows were stuffed with pigeons' feathers. It was sometimes the practice to arrange the bed of a sick person parallel with the boards, and in 1891 the bed of an aged woman at Symondsbury was removed by her rustic friends from under a beam, because 'her'll die so hard' if she remained in that position. In 1872 a boy was drowned in a stream near Sherborne, and the following expedient was resorted to in order to find the body. A piece of bread having been cut out of a loaf, a little quicksilver was poured into the cavity, and the loaf was thrown into the river at the spot where the lad had fallen in. The loaf was expected to float down the stream until it came and paused at the place where the body had lodged but, needless to say, it did no such thing.

Wilkinson Sherren

ATTEMPTED CONCEALMENT OF BIRTH

Sarah Highman, a respectable looking young person, was charged with attempting to conceal the birth of her child, at Shaftesbury. Mr Collins prosecuted, and Mr Bullen defended. Mary Highman, the sister of the prisoner, said they slept in the same bed, but witness did not know of her condition. Mr Wykes, surgeon, was called in. On the night of July 12th prisoner was very ill, and early—about four o'clock—the following morning went down stairs, being away

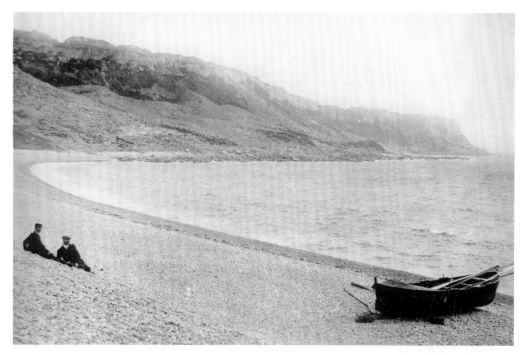

CHESIL COVE, PORTLAND

about a quarter of an hour. A newly-born child was afterwards found in the privy. Harriet Brockway deposed to the finding of the infant. Mr Wykes said that when he attended upon the prisoner she had consumptive symptoms, and she told him nothing about her actual condition. He was afterwards called in, when he discovered that she had just become a mother; she stated, on being questioned, that the child, when quite dead, had been put into the privy. When the child was discovered he found that it was fully developed, and that there were no marks of external violence. PC James, of Shaftesbury, deposed to charging the prisoner with concealing the birth of her child. She replied that it was dead. In her box he found some articles of baby linen. Mr Bullen, for the defence, said the sole question was whether his client disposed of the child with the intent alleged. He submitted that the birth was accidental, and that there was therefore no concealment. Prisoner was found guilty, and sentenced to four months' imprisonment.

Dorset County Chronicle and Somersetshire Gazette,
31 July 1873

BEACHCOMBING

With time on my hands, I was able to develop my inclinations for the delights of beachcombing. Perhaps there is a certain amount of vagabondage in most of us, but beachcombing in Purbeck is entirely divorced from any idea of laziness. It was no use playing the happy vagabond on the sunny beach if you intended to carry home a load of wood about a hundredweight, as it meant climbing over four hundred feet above sea level with that load, and never less than two miles the shortest way home. At first such a load and such a path will exhaust a really strong man, not only because he may be unused to carrying things on his back, but because the rope

BEACH, BURTON BRADSTOCK

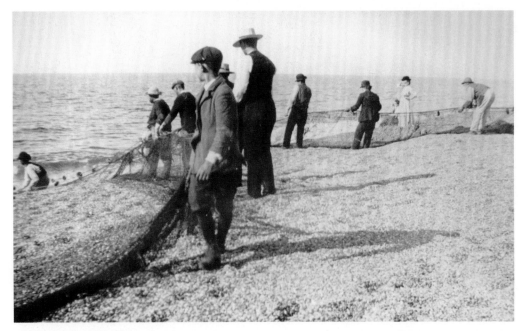

FISHING, ABBOTSBURY

cuts in the shoulder so sharply that the pain itself is weakening. But if a man intends to keep a fire going he has to go every day, and in that way he certainly is getting enough exercise to keep himself from getting slack.

But there was far more in it than that to become a successful beachcomber, and I was not content to be less efficient than any other man who walked the shore. It was necessary to know about the tides, as there were many places where it would be dangerous to be caught by a rising spring tide, and it was no use expecting to find anything newly washed up as long as the wind was off the land. Then the man who had taken the trouble to lay in hidden stores amongst the rocks had a chance to catch up on his transport, providing of course that no outsiders had discovered his store and broken the unwritten law that anything 'put up' belonged to the man who originally found it. I have known a man walk the beach without finding anything and then take something I had 'put up' for another time, but he would come, and explain how and why he had taken it, which of course made it perfectly in order.

There was rivalry to be the first along the beach after a bit of a blow on shore, as there was always a chance of finding something more valuable than firewood; but only outsiders broke the rule, and the worst offenders were visitors who rented houses in the district and filled their outhouses with timber they never had a use for. When a man who could afford to rent a furnished house all the year so that he could spend a few summer weeks there, carried home wood and stored it uselessly, it is difficult to explain why he did so, unless he had a streak of miserliness in him.

There was a time when I walked the beach every day except Sundays—even then Sunday as a day of rest was an institution I would not willingly destroy. Hot or cold, wet or fine, sometimes alone and sometimes with others, I set off down to the shore, and then perhaps walked miles over rocks and sand. Many a time I had the whole length of the beach to myself, and, looking back, there would be only one set of tracks along the virgin sand. An overhanging cliff above shut off the world, and at sea there might be nothing in sight except perhaps one smudge of smoke on the horizon very far away. And I might find anything. I do not necessarily mean things of value, although I did find my share of them. There was quite an excitement in seeing little useless things thrown up there from many parts of the world—things some men did not even stop to notice. It was even interesting to watch the growth of some strange plant springing up in a heated corner of rotting seaweed where a winter gale had thrown a seed from some far country. The next winter gale on high tides would sweep it away again, but many a foreign plant has flourished for a while under the Purbeck cliffs with very little chance to get a real foothold where it could survive.

It was then that I loved the beach and had ideas of living there. There were several places where it would have been easy to build a shack of the driftwood at hand—small slopes just above the highest tides, with a trickle of

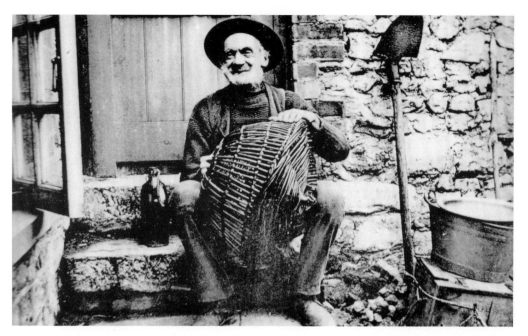

FISHERMAN, LYME REGIS

water nearby, and where for at least half the time the sea would have stopped anyone coming near. In theory it would have been good to live there and learn again to have very few wants, and even those wants could be postponed while there was the constantly changing beach to watch. It is a dull-witted man who is not excited by having to work in conjunction with the tides. The very inexorableness of all that water reaching its ordered height should make any man pause in his conceit, because no human power can alter it. Yet it also gives a man a sense of his mental achievement, because he can determine exactly where the highest water will reach at the given moment when the tide sinks back. And the sea never seems loath to give up its flow; it reaches its high-water mark for the day, and then obediently drops away, as if with regret that it has so much work to do elsewhere.

The sea is cruel, and has taken several of my friends out of this life; but along the shore to me it never seemed vindictive, despite its almost personal interest in anything it could reach and feel around. I have known a high wind rip and tear until it had everyone's nerves on edge, and still the wind savagely struck at everything within reach. To me it was like some jealous god or devil which turned back to ravage its victim out of sheer maliciousness, and in return I gave back rage for rage, however impotent it may have been.

But I have sat with a fisherman in the back of his boathouse and watched the sea licking up the floor with every wind-driven wave. It was the highest water anyone had known for years, and I expected to see his boat go floating out with all the loose things on the floor. But we knew there was a limit, and that the sea would give up like a good sportsman, and the fisherman sat with his watch in his hand, and at the proper minute he said, 'Well, that's as high as it will come, and it will be slacker next time. We're not going to lose the boat this time.' I could merely watch the wet floor at our feet, and, sure enough, not another quarter of an inch was wetted, and in ten minutes the last few inches were beginning to dry off. The sea was cruelly impossible to appease, but it never cheated.

It would have been easy and interesting to me to build a shack on one of those level places just above high-water mark, where once great rocks had fallen out of the cliff, and when they were large enough to resist the sea, other fallen material had remained behind them to form a platform at the foot of the cliff. Perhaps they are temporary, in that one day the sea will lick between two rocks and suck out all the loose stuff, but I should be willing to risk that, as they will not go in one tide. A man should be able to live there without interference, as no one could use the land; it certainly fell out of some man's cliff-face, so I suppose, strictly speaking, they could claim it. That is, claim to prevent anyone else using it, but the sea will decide it finally. And if I had attempted to live there, it is more than likely some landowner, with perhaps thousands of other acres, would have come down to turn me off

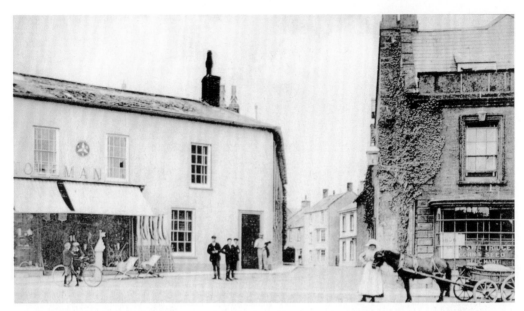

BEAMINSTER

his fallen rocks, and that may have led to broken heads.

There was one place where no landowner could have tried to turn me off. I used to look at a big rock lying between tides, which was never wholly covered, no matter how big the sea or high the tide. It was big enough to contain a small room above the water level, and I could have drilled a chimney through the highest part. No one could claim that, and only twice a day was it free. Probably I should have soon got tired of living there, but I measured that rock, and have worked out how long it would take to chip out a room that would be big enough.

Sometimes we used to compete who could carry the heaviest load home. In time I could carry a hundredweight without undue strain; but there were some things which could not be halved, and we carried loads which would break my back now. Sometimes we staggered several miles amongst slippery rocks, and then climbed the four hundred odd feet which had to be surmounted whatever path we used, and some paths needed hands as well as feet, so it was harder than going up a four-hundred-foot stairway.

Yet, not satisfied that we were keeping up our moral integrity by working harder than any coolie porter, I decided to save some planks which were suitable and build a boat. Even then it meant many long hours of sawing and shaping, as no two pieces of driftwood are the same size or shape; but gradually the boat took shape, although by no means a beautiful shape. I enjoyed the building of that boat, and although it was never a success on the water, because there usually was as much sea inside it as out, I never regretted the time and work spent on it, because it proved to me that a man without work did not necessarily become a moral and physical wreck.

Eric Benfield

BE'MI'STER

Sweet Be'mi'ster, that bist a-bound
By green an' woody hills all round,
Wi' hedges reachen up between
A thousan' vields o' zummer green,
Where elems' lofty heads do drow
Their sheädes vor hay-meäkers below,
An' wild hedge-flow'rs do charm the souls
O' maidens in their evenen strolls.

When I o' Zunday nights wi' Jeäne
Do saunter drough a vield or leane,
Where elder-blossoms be a-spread
Above the eltrot's milk-white head,
An' flow'rs o' blackberries do blow
Upon the brembles, white as snow,
To be outdone avore my zight
By Jeane's gay frock o' dazzlen white;

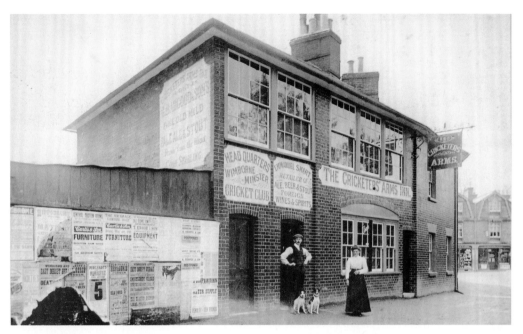

THE CRICKETERS' ARMS, WIMBORNE

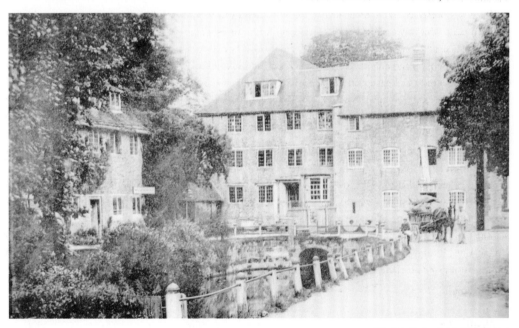

THE MILL, GILLINGHAM

Oh! then there's nothen that's 'ithout
Thy hills that I do ho about, —
Noo bigger pleace, noo gayer town,
Beyond thy sweet bells' dyen soun',
As they do ring, or strike the hour,
At evenen vrom thy wold red tow'r.
No: shelter still my head, an' keep
My bwones when I do vall asleep.

William Barnes

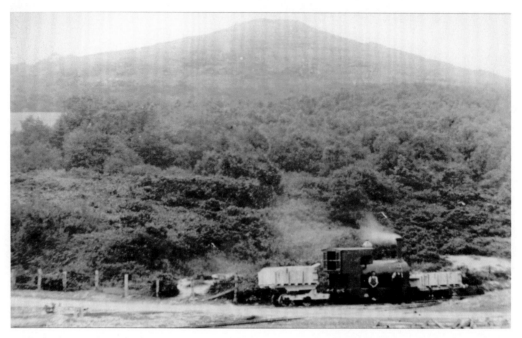

BARROW & CLAY ENGINE, CREECH

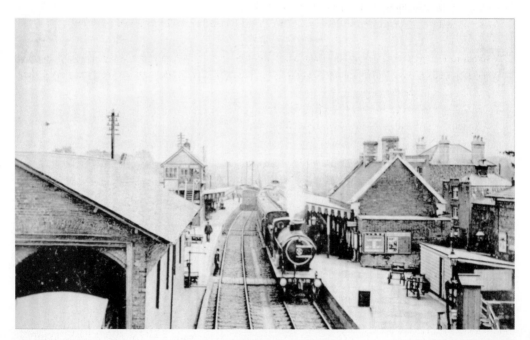

BLANDFORD STATION

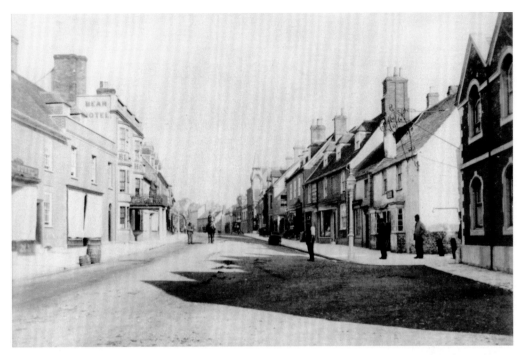

HIGH STREET, WAREHAM

A TRIP WITH TENNYSON

Friday, 23 August. Very fine. Steamer 11.40 to Yarmouth [Isle of Wight]. Tennyson on the quay, also his brother Frederick and two daughters. A. T. is going to Lyme Regis alone.

'I have wanted to see the Cobb there ever since I first read *Persuasion*. Will you come?'

Can I possibly? Yes, I will!

We cross to Lymington. I rush up and make hasty arrangements at Custom-House and lodgings; then off go A.T. and I, second class, to Dorchester. A. T. smokes. (T. is a great novel reader, very fond of Scott, but perhaps Miss Austen is his prime favourite.)

In our carriage a cockney Clock-winder, who gets out at every Station to regulate the Railway Company's clock.

Once safely *incognito* T. delights in talking to people, but touch his personality and he shuts up like an oyster. Ringwood, Wimborne, Poole harbour, Wareham (mounds), Dorchester. Walk in the warm afternoon, through stubble fields and reapers at work, to the grand old Keltic fortress now called 'Maiden Castle', view the great green mounds, and he on a slope looking over autumnal landscape. Then descend and return, finding cornflowers and 'Succory to match the sky'. Shall we stay tonight at Dorchester? T. vacillates, at last agrees. We go to the 'Antelope', rooms not good—out, and into the Museum, up a backyard—British antiquities, Roman pottery, etc. High Street, at its foot a clear little river, *the Frome*. A tipsy cobbler accosts us. River-side walk through meadows. County jail looks like a pleasant residence. Return by back street to the 'Antelope', which produces a pint of good port at dinner.

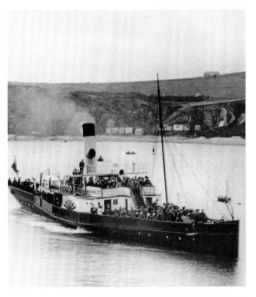

STEAMER, LULWORTH COVE

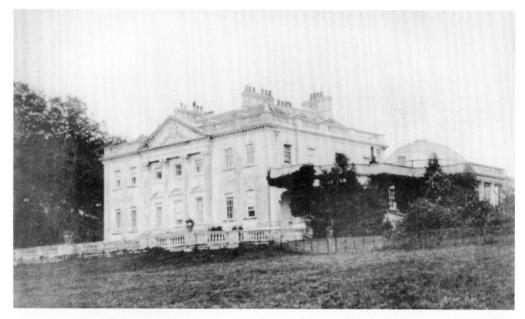

CAME HOUSE, WINTERBOURNE CAME

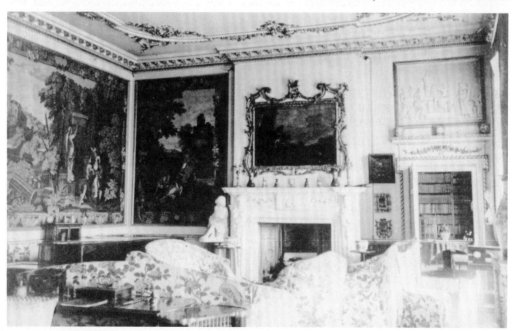

DRAWING ROOM, CAME HOUSE, WINTERBOURNE CAME

The twilight being fine I propose that we should visit William Barnes, whom T. personally knows, and whose poems in the Dorset dialect T. knows and likes. I show the way to Came Vicarage, where I had enjoyed hospitality from a Saturday to a Monday a year or two before. The cottage-parsonage lies in a hollow among trees about a mile from Dorchester, separated from the public road by a little grass-plot and shrubbery. We find the gate by starlight and reach the house door between 9 and 10 o'clock. The worthy old Poet-Vicar is truly delighted to see us, especially such a guest as T. (whose poetry, he used to say, has a 'heart-tone' in it).

Barnes himself lets us in or comes out at once into the passage—'Here's an honour!' Little Miss Barnes and Mrs Shaw, a married daughter, appear. B. says, 'put out something! put out something!' with hospitable fervour, tho'

WHITE HORSE INN, MAIDEN NEWTON

we lack no bodily refreshment. Barnes himself, by the way, though not a teetotaller, is an abstemious man, very plain and inexpensive in his diet. We are pressed to stay but can't. Talk of Maiden Castle, Irish duns and raths. T. tells his story of his car-driver, 'The King of Connaught'. Then we go, Barnes with us to near Dorchester, talking of British Antiquities, Wareham, Sun-worship, etc.

Saturday, 25 August. Dorchester—To Maiden Newton—Bridport. We start off to walk to Lyme Regis, leaving bag to come by carrier. Uphill, view of sea, down to Chidiock, pretty village, old church, flowery houses. We push on (as like two tramps as need be) along the dusty road to Martin's Lake, sea on one hand, shore hills on the other. Down a long hill to Charmouth, where we have beer and cheese in a little inn, then T. smokes in the porch and chats to the waitress. She says she is from the Isle of Wight. 'So am I,' says T., 'what part?' 'From Cowes,' says the girl. 'I come from Freshwater,' says T., which surprises me—but he revels in the feeling of anonymosity. We see Lyme below us and take a field-path.

Down into Lyme Regis, narrow old streets, modest little Marine Parade. 'The Cups' receives us in the fair plump good-humoured person of a House-Keeper Barmaid. T. gets a good bedroom and I a tolerable one; we go into garden sloping down-hill and out by some back steps to a Mrs Porter's, where the F. Palgraves are lodging—not in.

Back to 'The Cups' and order dinner; then by myself up steep street to top of the town, pleasant, view of shore and headlands, little white town far off. Dinner. Then T. and I out and sit on bench facing the sea, talking with friendly openness. Marriage—'how can I hope to marry? Some sweet good woman would take me, *if I could find her.*' T. says, 'O yes,' adding, 'I used to rage against the social conditions that made marriage so difficult.'

Sunday, 25 August. Lyme Regis. Very fine. T. up first and at my door. He has been on the Cobb, and eats a hearty breakfast. We go down to the Cobb, enjoying the sea, the breeze, the coast-view of Portland, etc., and while we sit on the wall I read to him, out of *Persuasion*, the passage where Louisa Musgrave hurts her ankle. Palgrave comes, and we three (after Manor House and some talk of Chatham) take a field-path that brings us to Devonshire Hedge and past that boundary into Devon. Lovely fields, an undercliff with tumbled heaps of verdure, honeysuckle, hawthorns and higher trees. Rocks peeping through the sward, in which I peculiarly delight, reminding me of the West of Ireland. I quote—

Bowery hollows crowned with summer sea.

T. (as usual), 'You don't say it properly'—and repeats it in his own sonorous manner, lingering with solemn sweetness on every vowel sound—a peculiar *incomplete* cadence at the end. He modulates his cadences with notable subtlety. A delightful place. We climb to the top, find flat fields, and down again. Stile and path—

WEST BAY

agrimony—we sit on a bank, talk of Morris, Ned Jones, Swinburne, etc. Whitechapel Rock. Then return by winding paths to the town. Miss Austen, Scott, novel writing. P counsels me to write a novel. Inn, dinner, fat waitress, port. In the coffee-room a gentleman, who joins in conversation—High Church, etc., State of England—and speaks well but guardedly. T. talks freely—human instincts, Comte, etc.

We go to Palgrave's, who says, 'thought you were not coming'. They smoke. When T. and I are walking back to the Inn he takes my arm, and by and by asks me *not* to go back to Lymington. I (alas!) have to reply that I must. 'Well then,' says T, 'arrange your business there and come back.' I doubted if I could. 'Is it money?' says he—'I'll pay your expenses.' Most delicious! that the man whose company I love best should care about mine. Most mortifying! for I am tied by the leg.

William Allingham

SANITARY STATE OF BRIDPORT

Many of the private courts in Bridport are badly paved, so that water and slops are not properly carried off. The rain-fall of these courts is got rid of by gutters on the surface, or more generally, by drains just under the surface, the inlets to which are sometimes trapped, sometimes not. These drains remove, besides rain, the refuse water of the houses, a part of the soakage from the dust-bin or cesspool, and probably, often the contents of chamber vessels. Their contents are usually offensive, and, as they frequently have openings close to the door-sills of the cottages, are often complained of by the residents.

The small superficial drains of the courts, and the house drains of the main streets, discharge themselves into public sewers that run in the course of the principal thoroughfares. The sewers are generally two for each street, one under the roadway receiving drains from the one side; the other, behind the opposite houses, receiving the drainage of that side of the street. They are either brick, or half-barrel drains, or square stone gutters. None of them exceed twenty inches in diameter, and are only meant to carry off rain and the liquid refuse of houses. The public sewers are generally so near the surface, that any house with a basement has to adopt special means for draining it, and in some instances, adjacent courts cannot be drained for want of fall to the public sewer.

The fall of the public sewers is good, where the street has a good incline; but it is, in many places, insufficient, where the road is nearly on a level. In several such instances, sewers have been found half full of solid matters, and have sometimes been reported quite impervious, even to liquids.

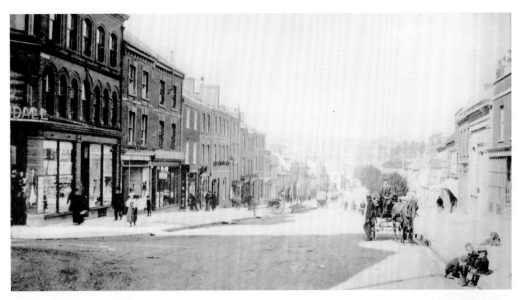

WEST STREET, BRIDPORT

The solid refuse of Bridport is, almost universally, caught in cesspools. There are, indeed, in the borough, some seventy water closets, but the great majority of these discharge themselves, as the ordinary privies do, into cesspools, their liquid overflow passing into the drains. Only a very few of the better class houses send the solid matters of their water closets into the town drains. The cesspools, are, in most instances, brick vaults, and the Bye-laws of the Local Board enact that all future cesspools shall be made water-tight. But in many existing instances, the cesspools are mere excavations in the soil. The cesspool is usually placed directly under the privy, in such a way, that the flooring has to be disturbed to empty it of its contents. In this respect, the cesspools differ from the Lancashire "middens;" which receive also the dust and ashes of the household, substances, which, to a considerable degree, act as deodorizers to the contained soil. A few houses, at the lowest part of the town, drain straight into the river, on the surface of which, soil was seen floating.

The houses of well-to-do people, are, generally, furnished each with its own privy; but the cottages tenanted by the artisan and labouring classes have usually only one privy to several houses. Perhaps the general proportion throughout the town is one privy to every four such cottages. But the following is not a solitary instance: 'Cox's Court' is composed of four houses, in South Street, a row of seven cottages behind, two others at a little distance, with spinning-walks and workshed. Two privies, contiguous to each other, are situate at the side of the spinning-walks, at some distance from the main group of buildings. They afford the only accommodation for the thirteen houses, with their 47 residents, as well as for other workpeople engaged in the spinning grounds. The vault of these privies was found full up to the floor level, and the door of one of them was off its hinges. In such an instance, as this court, the people profess to take their night vessels past their neighbours' houses, to empty them into the privies some hundred yards off, but it is certain that they often do empty them into the drain at their door sill, or else upon the dustbin, if it happen to be handier than the privy.

There is no rule how often cesspools are to be emptied: that is held to depend upon the size of the vault. In practice, they are emptied only as they are full, every few years; sometimes, not for a dozen years, or more. Even thus, they have been emptied much more frequently since the Local Government Act was adopted, than formerly.

The privies and the drains, in most of the courts, smell very offensively, and where there is but little movement in the air, the bad smell is perceived through the whole of a court, even at a considerable distance from the privy.

Ashes, and vegetable refuse from houses, are commonly stored in large uncovered ash-pits, one to each court, but even these are sometimes wanting, and refuse is piled carelessly in some corner. The contents of the ash-pits are apt to get soaked by rain and waste water, and bad smells are constant from the decomposition that ensues. Moreover, as has been said, they often receive other matters that should not be thrown on them.

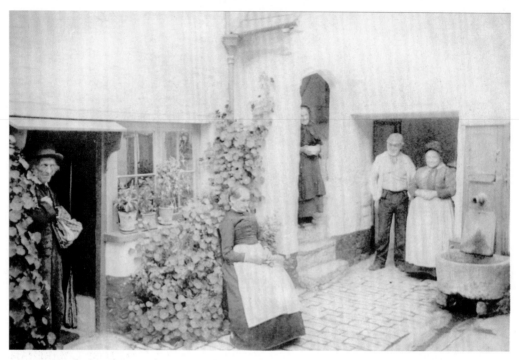

FRIENDS' ALMSHOUSE, BRIDPORT

There is no public provision for emptying the ashpits of the town. A portion of their contents is laid on the gardens, or otherwise got rid of, but they are not systematically, and very rarely completely emptied. They constitute another, and a serious source of contamination to the air.

Some few instances were observed of animals being kept close to houses in dirty and ill-constructed sheds and sties. These cases are much less numerous since the Inspector's appointment. The slaughter-houses of the town are well regulated, and mostly in good condition.

The soil of Bridport consists of ferruginous sandy marl, alternating with stiffer clay, forming the hill on which the town stands. This is the marlstone bed of the lias. Underneath this, is a bed of clay, sloping uniformly to the south-east, and representing here the lower has. The marlstone bed is thickest in the highest parts of the town.

The water supply of Bridport is from wells sunk 15–30 feet into the marlstone and (at the lower part of the town) into the subjacent clay. The water of many of these wells habitually becomes turbid after rain. In some, the water has been known to smell offensively* Cases have been discovered where surface drains actually discharge themselves into a well. At the lowest lying parts of the town, the water appears to become impure to the senses more frequently than in the upper parts, and drinking water is largely obtained from a spring supplied from the hills across the river in Bothenhampton parish. This water is described as being constant in flow and appearance. Two gentlemen's houses that stand alone above the town,

NET-MAKING FACTORY, BRIDPORT

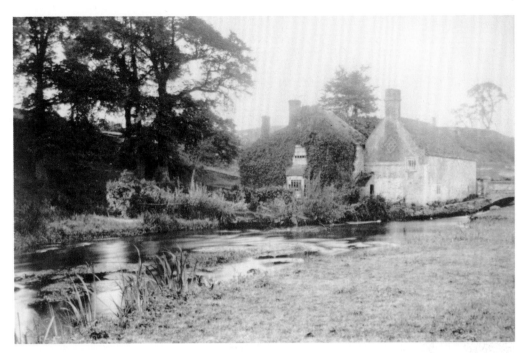

OLD MILL, WAREHAM

on the north, are supplied by deeper wells that go below the marlstone bed into the lower lias. Their water is of very constant characters, and is, probably, derived from the surface of the clays. The workhouse is also supplied with water from a deep well.

*Described in a local broad-sheet as 'looking yellow, tasting strongly; with a nice good drainy smell.'

Dr Buchanan's Report, 1864

SCARCITY OF LABOUR

Few people could be better qualified to speak of the rural conditions of Dorsetshire than the well-known authority on natural history, the Revd Octavius Pickard-Cambridge. Mr Cambridge, whose ancestors, I believe, have been connected with the county for a great number of generations, has since 1868 been rector of Bloxworth, Wareham, of which parish, I think I am right in saying, his father was the squarson. In kind response to my request for information on various points, Mr Cambridge said that in Dorsetshire, as elsewhere, the scarcity of agricultural labourers was an undoubted fact, although he thought that there were still a fair number of them floating about the county; that actual scarcity was made to appear greater than it is by the fact that the labourers did not remain in the service of the same farmer, as many of them changed their situations every year. This was, he believed, owing partly to that universal feeling of restlessness which now-a-days seemed to pervade all

ONE MAN AND HIS DOG

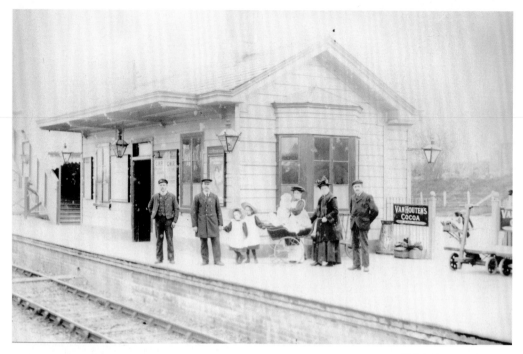

EVERSHOT STATION

kinds of labour, agricultural and domestic, but, on the labourer's part, even more to the lingering influence of the teaching of Joseph Arch.

Arch's great maxim was, 'Don't bind yourself at any rate for longer than a year', that is, from Lady Day to Lady Day. The labourer, therefore, would make his bargain at the busy time, while the farmer retaliated by dispensing with his services at slack times, as in winter. As yet their employers could hardly be said to have tempted the labourers to remain by means of adequately increased wages, shorter hours, or other advantages. They preferred to run the risk of being left underhanded, trusting to a quick, fair-weather harvest, when the use of machinery enabled the work to be accomplished with half the number of labourers who were formerly employed, to the great relief of the wages bill. To one class, however, higher wages were now given—namely, to lads of eighteen or twenty and unmarried men, as distinguished from married men with wives and children, because the young fellows and bachelors, having no impediments, can tie all their worldly goods in a bundle on their backs and depart at a week's notice. Also the clergy and others, naturally interested in bettering the condition of lads and young men, assist the general exodus from the country by finding them situations as policemen, railway porters, gardeners, gamekeepers, domestic servants, &c., in all of which occupations they find not only better pay, but with it the attractions of higher companionship and more recreation. If the country-side and its labours offered a better wage and more of such advantages, with good, but not necessarily larger dwellings, he thought that the rush to the towns would be materially checked.

H. Rider Haggard

THE PROPOSED RAILWAY

A public meeting of the inhabitants of Swanage and the Isle of Purbeck to promote the scheme for forming a line between Wareham and Swanage was held on Friday afternoon, at the Mowlem Institute, Swanage. Mr G. Burt, of London, presided. It was stated the line was proposed to be about 10 miles long, intermediate stations being established at or near Stoborough, Corfe Castle, and Langton. The Chairman explained that he and others had waited upon the directors of the London and South Western Railway, and that there was a probability of their rendering material help in the undertaking. Mr Smith, C. E., of London, the engineer engaged for the line,

BLACKSMITH

explained that several of the shareholders, including Mr Bond and Colonel Mansel, had agreed to take out in shares the value of their land passed over by the railway. The Chairman, as also Mr J. E. Robinson, subscribed £1,000, and other shares were taken. It was resolved to make the necessary application to Parliament if sufficient capital was raised, and the committee were authorized to continue their negotiations with the South-Western Company and the landowners of the district. It transpired during the course of the proceedings that Lord Eldon, the largest landowner in the district, was opposed to the scheme, but a hope was expressed that His Lordship would not oppose the Bill in Parliament. About 150 of the stonemasons of Swanage sent in a memorial in favour of forming the line.

The Western Gazette, 19 October 1877

A BLACKSMITH QUITS

Perhaps it was a fit of temper that had made him go to live at Swanage from Langton Matravers, as he had carried on his business at Langton for a long time. He told me that the quarrymen up there would not or could not pay him for the work he did, and as most of his trade was with them, he had to make a move. Why he should think that similar quarrymen at Swanage would pay up better is hard to say, but it is interesting to know that he did not close his Langton shop, as any other man would. He said that men would keep on bringing or sending their tools to him, and by the time he had finished that particular job some more work would arrive, until it seemed he would never get away.

MITCHELL'S FORGE, CORFE CASTLE

STONE QUARRY, LANGTON MATRAVERS

In the end he took his own method of showing that he really was finished with them. One day he looked up from his fire and saw two more men in the doorway weighted down by the bundles of tools over their shoulders, and, really angry at last, he swung his great pincers and swept the whole fire at them. Those two men are now no longer young, but they will never forget how they learnt that he really was not going to accept any more work from them. They remember how he loomed over them, with his naked chest covered by a great beard, and how suddenly the big pincers—looking as terrible as something out of a religious picture representing the grip of the infernal regions—flashed through the roaring flames and threw great streams of fire at them. They scrambled out of the shop in a great hurry with their tools, and my grandfather was able to close up his Langton business.

Eric Benfield

AMONG THE QUARRIES

A soft range of green hills; in spring one broad expanse of golden gorse, in autumn purple and pink with heather, and beyond these another range, where gigantic moles appear to have been at work, turning out—instead of the dark brown mould that usually marks their progress, great grey heaps of stone, that on nearer approach look like the remains of a dead and gone city. From the quarries themselves we look straight down into the little town of Swanage, over the broad blue bay to Bollard Down, where the seagulls are whirling slowly to and fro in the quiet air, and below which the twin-rocks—locally called 'Old Harry and his Wife'—glitter in the sunshine, as if carved out of solid ivory. Everything is very still just now among the quarries, and we can examine the curious places from which most of the stone that once paved London is taken, and where the work is very slack at present, and we can almost see, too, the immense masses of stone called 'bankers' that line Swanage shore, spoiling that otherwise lovely little watering-place, and giving it the appearance of an over-crowded churchyard. The bankers extend one side of the bay, and thence the stone is shipped into carts with enormous wheels, that go far out into the sea to the barges, whence the stone is again shipped into vessels—a costly process, that it is believed the coming railway will do away with. The railway will, should it come, do away with a great many other things—with the quiet of the little valley below the quarries for example, where the dusky gloom of the midsummer foliage is gradually assuming autumn tints, and where the oaks all slope one way, as if a knife had been drawn across them, and speak volumes for the strength of the wind, that comes moaning along the valley through the gap in the hills by Warbarrow. When the

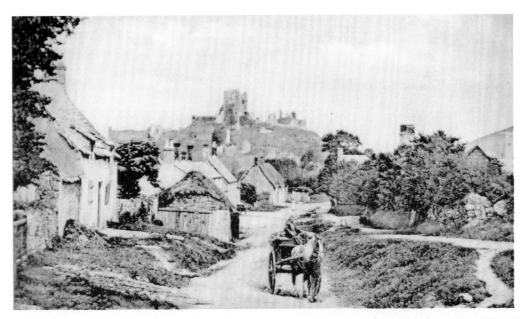

CORFE

stone comes down sheer on the shore it may put a sudden end to the sleepy silence of the occasional farms, where nobody ever seems to go, and where at times the mist rolls up from the sea and encloses them as with a veil and it may put an end to, it must certainly alter—many of the curious customs that rule and regulate the quarries' lives. The quarries themselves are separate, each surrounded with its own particular wall, and in most cases having its own shed, where in wet weather the quarrier can sit chipping his stone into portable shape, and which is sometimes the home of a patient, shaggy donkey, whose life is spent in going round and round, dragging miniature trucks laden with stone up the small incline leading to the quarry itself. But in these days of Free Trade it is curious to find existing a body of men who are bound by a charter that is rigorously obeyed, to keep the working of the stone in the hands alone of the Freemen of the quarries. To be able to take up one's freedom, one must be the legitimate son of a Freeman; and as the original holders of the quarries were few in number, this has caused an amount of inter-marriage, that has had a serious effect upon the mental health of the aborigines, and often two or three unfortunate creatures are during the year obliged to be taken away to the county asylum. Once during the twelve months the quarriers meet at the little building known as the Corfe Town Hall, and there solemnly read over their charter, and on that occasion, viz., Shrove Tuesday, 'Free boys' can claim or take up their Freedom, having previously expressed their intention of doing so by assembling on Candlemas Day and parading Corfe and Swanage streets headed by a band and accompanied by the stewards of the quarriers or marblers, as they are called in the old papers relating to the body. The man who is anxious to take up his freedom must be 21, up to which age his wages belong to his parents; but after he has signed the roll of Freemen, paid his fee of 6s. 8d. (half a mark in the old days), and provided a penny loaf, made on purpose by the bakers of the place, and two pots of beer, he becomes his own master and has a quarry all to himself, should he choose. Then, should he take to himself a wife, he has to pay to the stewards what is called a marriage shilling, and should he omit this, his wife loses all interest in the quarry, and cannot take an apprentice to work for her, as she would otherwise have been able to do. The parade of the 'Free Boys' on Candlemas Day was formerly rather a riotous proceeding, as they used to claim the privilege of kissing any woman they happened to meet, which sometimes led to awkward rencontres. This we believe is not now insisted on, being one of those customs better honoured in the breach than the observance. Nothing will induce the quarriers to allow strangers to work among them, and a person who was employed in a quarry at Swanage who was neither a freeman nor a son of a freeman, was instantly objected to, and had to leave, no grace being allowed him, which is rather a stricter rule even than that to be found in the neighbouring island of Portland, where a stranger can have a week's work, but after that must at once take his departure. If he does not, he is taken down to the sea, and shown a plank,

CONVICTS AT WORK IN THE QUARRIES, PORTLAND

GREEN AND FURZE ISLANDS, POOLE BAY

up which he is requested to walk. As the plank is so prepared that the result of a promenade thereon would be instant immersion, the would-be quarrier departs, doubtless shaking the dust of Portland off his feet. The Swanage men will not even give the week's work, and keep rigorously to themselves, according to their charter, which is kept in hands of the warden, who lives at Langton, a straggling village above Corfe, in the very heart of the stone country. The wardens are two in number. One is appointed to act for Corfe itself, and he is called the Town Warden; the other for the parts of Purbeck out of the borough itself; who is called the Country Warden. The great day is, as we said before, Shrove Tuesday, and then the officers are nominated by the outgoing ones, subject to the approval of

the general meeting; and should the nominee be considered an unfit person, another is regularly elected by the majority. After this is done, and the Freemen are sworn in, the ceremony of kicking the foot-ball begins. The foot-ball is provided by the man who was last married among the Freemen, and is presented in lieu of the marriage shilling. Should no Freeman have married since the last Shrove Tuesday then the old foot-ball is used. It is the custom to kick it from Langton, through Corfe, down to a little quay on the river that meanders slowly through the heath to Poole harbour, called Oure; but as the kickers were generally any of those among the crowd that looked on who could get at it, it is now, we believe, discreetly carried, in company with a pound of pepper, as an acknowledgement to the Lord of the Manor in respect of the way to Oure, and the cottager who lived there used to provide pancakes for the stewards, who brought the ball and pepper, on Ash Wednesday, when the Shrove Tuesday fuss was over. The charter is supposed to date from the building of the

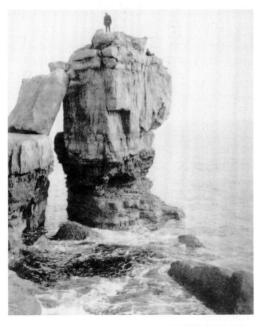

PORTLAND BILL

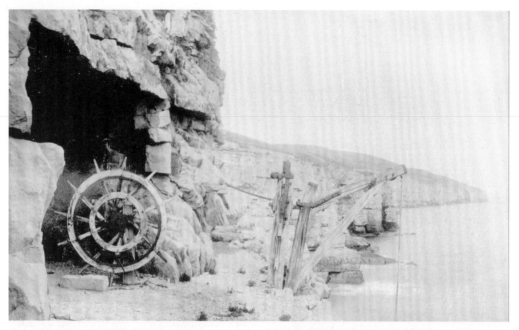

COASTAL QUARRY, HEDBURY, SWANAGE

castle, but the really existing one bears the date, we believe, of 1551; though the Marblers, as they are there called, always insist on an earlier one. Judging from what we have seen, the originators must have been a curious, secretive set; very strong on moral grounds, for they will not even taken an apprentice who is base born or whose parents are of 'loose lyfe'; neither shall the apprentice himself either be or have been a 'loose liver', and no man of the company is to 'undercreep' his fellow-tradesman or take away from him any bargain of work, of his trade, upon the forfeiture of '*flive* pundes'. Neither are the quarries to be too close together, a hundred feet above and under ground being insisted on, though the quarriers of these later day have not always stuck to this. The stone runs in blocks, with dry clay lines between each block, which enables the quarrier to insert his instruments and work out the stone without resorting to blasting and this clay deadens somewhat the sound of the worker underground and over. One of the men used to work at night, gradually grating into his neighbour's ground; while, curiously enough, his neighbour, being struck with the same desire for other people's property, was working away also at night with an eye to appropriating the stone. One night the last layer of clay was divided, and they met, or rather the glimmer of the candles by which they were working caught the eyes of the two men simultaneously. Without a word they caught up a lump of clay and filled up the hole, and, discreetly retiring, no one was the wiser, or else doubtless the forfeiture of '*flive* pundes' insisted on by the charter as a recompense would have had to be paid 'unto the owner of the quarr unto whom the offence should be dunn'. The stone and also the Purbeck marble runs straight through the hills, the marble appearing at Peveril Point, at the end of Swanage Bay, where again it comes out at Warbarrow, the other extremity of this line of hills. The curious Tout itself was once quarried, but this was very easy work, for the strata came right down on the shore, and as the end was cut off more slipped down by its own weight, and all the men had to do was to cut it off and ship it to Weymouth. Luckily, the owners saw how the Tout would ultimately be damaged, and put an end to it before the work of destruction had gone too far. Quiet little out-of-the-way Swanage that sleeps a melancholy sleep nine months out of the twelve, and just opens its eyes for the remaining three to blink at its crowd of visitors, has, it is believed, slept its last sleep, and another of the scarcely known lovely corners of England will be rampaged over by the ''Arrys' of civilization, and then doubtless the quarries will be thrown open, and their customs will become obsolete; but at present they exist as we have described them, and to all who really care for primitive, old-world customs and queer ways, we say Go to Swanage before the railway demon engulphs it, and wander for yourselves among the quarries, where the women still believe that a ride on a donkey's back to four cross-roads, or wearing a bit of hair clipped from the cross on a donkey's shoulder, is an

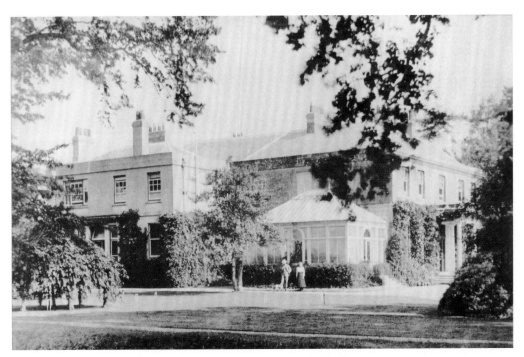

WRACKLEFORD HOUSE, STRATTON

infallible cure for hooping-cough, and where the men rule themselves and believe themselves to be quite outside the regulations and laws of ordinary humanity.

Wareham and Isle of Purbeck Advertiser and Swanage Visitors List, Friday 9 September 1881

UNCLE-COUSIN GEORGE

Uncle-cousin George introduced some very useful novelties. The most important, perhaps, was providing a better means of watering. My father bought one of the movable water-reservoirs which had recently been invented. This could be moved from place to place and a water-engine was also provided so as to avoid the difficulties of hand-watering. It was a good investment for the summer of 1868 was one of exceptional heat and scorching drought. The water-reservoir was also a great personal convenience to Uncle-cousin George himself. He was a burly man of exceptional vigour, and his appearance was made more imposing by a fine flowing and carefully trimmed red beard. On these blazing summer days he used first to fill the garden-tank from a fine pump which went down well into the chalk, then wheel it round to the stable and there sit in it as in a deep bath.

Another of his novelties was a mowing-machine which did away with the homely old scythe and hone which used to sound so pleasant when sluggards were taking one more turn on a summer morning. This also was particularly useful that year for it could provide a croquet-lawn (bad and small but up to the lowly requirements of those simple days) in front of the house. The first time that I ever saw croquet played was at Came Rectory where Mr William Barnes, the poet, was rector. It is a charming old thatched house surrounded by trees and famous for its daffodils and primroses which were supposed to be Spring's very vanguard in all that neighbourhood. My mother was so struck by the possibilities of croquet as a social entertainer that she ordered a set from London and the mowing-machine lent itself to the making of a 'croquet-lawn'. My mother was much given to hospitality. She loved entertaining and entertained very well. Besides providing rather lavishly for the many guests who stopped in her house, she was continually giving social functions to other Dorchester residents, which were greatly appreciated but very seldom, I think, 'returned'. It is quite true that these entertainments were simple, as befitted those simple refreshing days.

John Meade Falkner

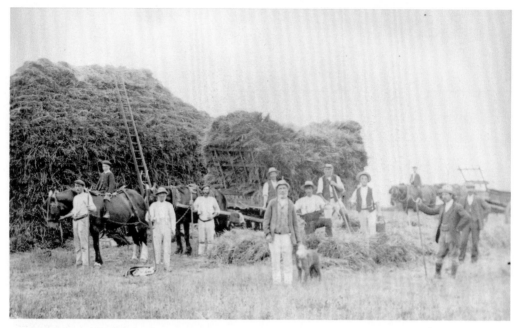

HARVESTING, TOLPUDDLE

TOLPUDDLE MARTYRS REMEMBERED

On Wednesday last, March 17th, being the forty-first anniversary of the conviction of the Dorchester Labourers, a great demonstration was held in a large tent, capable of holding 2000 persons, erected at Briantspuddle, the occasion being the presentation of a testimonial to James Hammett, one of the men transported.

Hymn on the occasion (to the tune of the Old Hundredth, 'All people that on earth do dwell'):

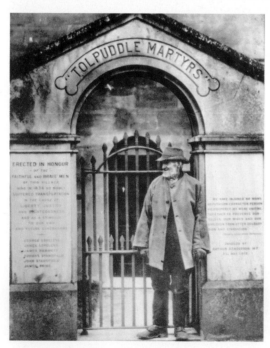

TOLPUDDLE MARTYRS' MEMORIAL GATE

We meet this day, free-men, combined,
Not as when unjust power's decree
Unto the felon's doom consigned
The pioneers of liberty.

No brute hoofs on our union tread,
No evil laws our free speech mar,
While honouring the illustrious dead—
The saints of labour's calendar.
We meet today to pay our grateful debt
To those who bore the felon's lot,
Their unjust judges names forgot,
The memory of the vile shall rot.

No stone may mark the exiles' graves
In distant lands beyond the sea
Who wore the clanking chains of slaves
Because they struggled to be free.

They need no storied urn or bust
Who once in yonder dungeon lay;
The tyrant's fame is turned to dust,
The felon's fame we sing this day.

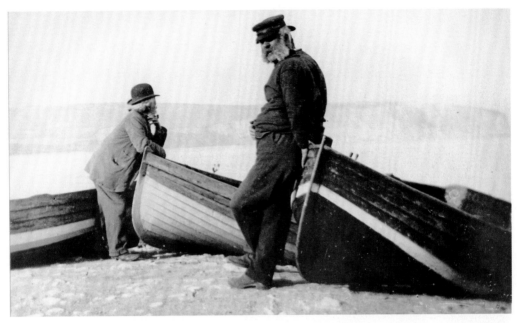

SWANAGE FISHERMEN

The life they lived to us imparts
Strength in the fight with brutal wrong;
We keep their memories in our hearts,
And wreath their names in flowers of song.

The Beehive, March 1875

SUCH NOBLE FISHING

'Fishing' was a great amusement. Though we never hesitated at rank poaching, results were poor enough. Minnows and a few dace were I think all that we could boast of, but the enjoyment was inexhaustible. Once indeed at Bockhampton where I was fishing from a bridge a fair sized perch took my hook, and as soon as the line was out again another was brought in. Then 8 or 10 were caught and in such excitement I managed to fall into a deep pool of the river and had much ado to get out. Never was such noble fishing, and when no more fish came I ran home in a draggled muddy state with pockets bulging with fish. My mother sent me to bed at once because I had gone to fish in my best suit but nothing could quench the exaltation of the occasion.

John Meade Falkner

GAMEKEEPER AND POACHER

THOMAS HARDY AT PLAY REHEARSAL

MEMORY RINGS

The roman amphitheatre where we sometimes played football was called Memory Rings. Antiquarian pundits in modern times have derived the name from *Malm*bury or the *chalk* burh, because the ramparts were made of chalk like all other earthworks in that neighbourhood. But it was probably Membury, and named after some tenant farmer for sheep are grazed there, and Membury is a comparatively common Dorset and East Devon name. I mention the place because there was a legend often in mind that on a summer day at distant intervals some had heard a trumpet sound and forthwith the seat-terraces which look down onto the arena were crowded with Romans, who had slept for centuries in the Roman cemetery outside the old town. Thomas Hardy has used the story in one of his novels, probably the Mayor of Casterbridge. I remember that on an Autumn day we were playing there and that an elbow struck someone in the face and made his nose bleed. While everyone was dropping pocket-knives down his back—an 'infallible' boyish styptic—someone shouted 'The Romans' and we rushed out of the place headlong. Perhaps it did not go for nothing that in the impressionable period of boyhood we should have been brought up in one of the most important Roman centres, and in the very focus of prehistoric civilization, surrounded with its giant earthworks. Who knows what influence on character such things may have?

John Meade Falkner

MUMMERS

For mummers and mumming Eustacia had the greatest contempt. The mummers themselves were not afflicted with any such feeling for their art, though at the same time they were not enthusiastic. A traditional pastime is to be distinguished from a mere revival in no more striking feature than in this, that while in the revival all is excitement and fervour, the survival is carried on with a stolidity and absence of stir which sets one wondering why a thing that is done so perfunctorily should be kept up at all. Like Balaam and other unwilling prophets, the agents seem moved by an inner compulsion to say and do their allotted parts whether they will or no. This unweeting manner of performance is the true ring by which, in this refurbishing age, a fossilized survival may be known from a spurious reproduction.

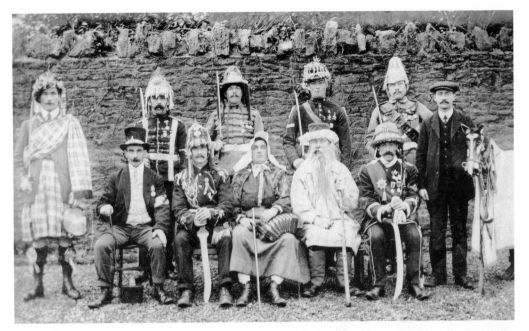

CHETNOLE MUMMERS

The piece was the well-known play of 'Saint George,' and all who were behind the scenes assisted in the preparations, including the women of each household. Without the cooperation of sisters and sweethearts the dresses were likely to be a failure; but on the other hand, this class of assistance was not without its drawbacks. The girls could never be brought to respect tradition in designing and decorating the armour; they insisted on attaching loops and bows of silk and velvet in any situation pleasing to their taste. Gorget, gusset, basinet, cuirass, gauntlet, sleeve, all alike in the view of these feminine eyes were practicable spaces whereon to sew scraps of fluttering colour.

It might be that Joe, who fought on the side of Christendom, had a sweetheart, and that Jim, who fought on the side of the Moslem, had one likewise. During the making of the costumes it would come to the knowledge of Joe's sweetheart that Jim's was putting brilliant silk scallops at the bottom of her lover's surcoat, in addition to the ribbons of the visor, the bars of which, being invariably formed of coloured strips about half an inch wide hanging before the face, were mostly of that material. Joe's sweetheart straightway placed brilliant silk on the scallops of the hem in question, and, going a little further, added ribbon tufts to the shoulder pieces. Jim's, not to be outdone, would affix bows and rosettes everywhere.

The result was that in the end the Valiant Soldier, of the Christian army, was distinguished by no peculiarity of accoutrement from the Turkish Knight; and what was worse, on a casual view Saint George himself might be mistaken for his deadly enemy, the Saracen. The guisers, themselves, though inwardly regretting this confusion of persons, could not afford to offend those by whose assistance they so largely profited, and the innovations were allowed to stand.

There was, it is true, a limit to this tendency to uniformity. The Leech or Doctor preserved his character intact: his darker habiliments, peculiar hat, and the bottle of physic slung under his arm, could never be mistaken. And the same might be said of the conventional figure of Father Christmas, with his gigantic club, an older man, who accompanied the band as general protector in long night journeys from parish to parish, and was bearer of the purse.

Seven o'clock, the hour of the rehearsal, came round, and in a short time Eustacia could hear voices in the fuel-house. To dissipate in some trifling measure her abiding sense of the murkiness of human life she went to the 'linhay' or lean-to shed, which formed the root-store of their dwelling and abutted on the fuel-house. Here was a small rough hole in the mud wall, originally made for pigeons, through which the interior of the next shed could be viewed. A light came from it now; and Eustacia stepped upon a stool to look in upon the scene.

On a ledge in the fuel-house stood three tall rush-lights, and by the light of them seven or eight lads were marching about, haranguing, and confusing each other, in endeavours to perfect themselves in the play.

PIGEON HOUSE, STOCK GAYLAND

Humphrey and Sam, the furze and turf cutters, were there looking on, so also was Timothy Fairway, who leant against the wall and prompted the boys from memory, interspersing among the set words remarks and anecdotes of the superior days when he and others were the Egdon mummers-elect that these lads were now.

'Well, ye be as well up to it as ever ye will be,' he said. 'Not that such mumming would have passed in our time. Harry as the Saracen should strut a bit more, and John needn't holler his inside out. Beyond that perhaps you'll do. Have you got all your clothes ready?'

'We shall by Monday.'

'Your first outing will be Monday night, I suppose?'

'Yes. At Mrs. Yeobright's:

[*For romantic reasons, Eustacia Vye joins the mummers for their performance at Mrs Yeobright's house.*]

At this moment the fiddles finished off with a screech, and the serpent emitted a last note that nearly lifted the roof. When, from the comparative quiet within, the mummers judged that the dancers had taken their seats, Father Christmas advanced, lifted the latch, and put his head inside the door.

'Ah, the mummers, the mummers!' cried several guests at once. 'Clear a space for the mummers.'

Hump-backed Father Christmas then made a complete entry, swinging his huge club, and in a general way clearing the stage for the actors proper, while he informed the company in smart verse that he was come, welcome or welcome not; concluding his speech with

> 'Make room, make room, my gallant boys,
> And give us space to rhyme;
> We've come to show Saint George's play,
> Upon this Christmas time.'

The guests were now arranging themselves at one end of the room, the fiddler was mending a string, the serpent-player was emptying his mouthpiece, and the play began. First of those outside the Valiant Soldier entered, in the interest of Saint George—

> 'Here come I, the Valiant Soldier;
> Slasher is my name;'

SNOWSCENE, LONDONDERRY, BLANDFORD

and so on. This speech concluded with a challenge to the infidel, at the end of which it was Eustacia's duty to enter as the Turkish Knight. She, with the rest who were not yet on, had hitherto remained in the moonlight which streamed under the porch. With no apparent effort or backwardness she came in, beginning—

> 'Here come I, a Turkish Knight,
> Who learnt in Turkish land to fight;
> I'll fight this man with courage bold:
> If his blood's hot I'll make it cold!'

During her declamation Eustacia held her head erect, and spoke as roughly as she could, feeling pretty secure from observation. But the concentration upon her part necessary to prevent discovery, the newness of the scene, the shine of the candles, and the confusing effect upon her vision of the ribboned visor which hid her features, left her absolutely unable to perceive who were present as spectators. On the further side of a table bearing candles she could faintly discern faces, and that was all.

Meanwhile Jim Starks as the Valiant Soldier had come forward, and, with a glare upon the Turk, replied—

> 'If, then, thou art that Turkish Knight,
> Draw out thy sword, and let us fight!'

And fight they did; the issue of the combat being that the Valiant Soldier was slain by a preternaturally inadequate thrust from Eustacia, Jim, in his ardour for genuine histrionic art, coming down like a log upon the stone floor with force enough to dislocate his shoulder. Then after more words from the Turkish Knight, rather too faintly delivered, and statements that he'd

SKATING ON SHERBORNE LAKE

EVANS' DORCHESTER DRAPERY BAZAAR

fight Saint George and all his crew, Saint George himself magnificently entered with the well-known flourish—

> 'Here come I, Saint George, the valiant man,
> With naked sword and spear in hand,
> Who fought the dragon and brought him to the slaughter,
> And by this won fair Sabra, the King of Egypt's daughter:
> What mortal man would dare to stand
> Before me with my sword in hand?'

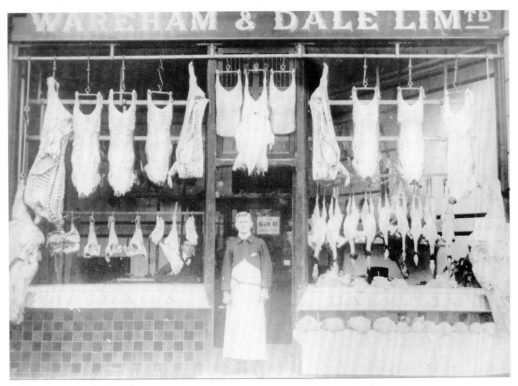

WAREHAM & DALE, BUTCHERS

This was the lad who had first recognised Eustacia; and when she now, as the Turk, replied with suitable defiance, and at once began the combat, the young fellow took especial care to use his sword as gently as possible. Being wounded, the Knight fell upon one knee, according to the direction. The Doctor now entered, restored the Knight by giving him a draught from the bottle which he carried, and the fight was again resumed, the Turk sinking by degrees until quite overcome—dying as hard in this venerable drama as he is said to do at the present day.

This gradual sinking to the earth was, in fact, one reason why Eustacia had thought that the part of the Turkish Knight, though not the shortest, would suit her best. A direct fall from upright to horizontal, which was the end of the other fighting characters, was not an elegant or decorous part for a girl. But it was easy to die like a Turk, by a dogged decline.

Eustacia was now among the number of the slain, though not on the floor, for she had managed to sink into a sloping position against the clock-case, so that her head was well elevated. The play proceeded between Saint George, the Saracen, the Doctor, and Father Christmas; and Eustacia, having no more to do, for the first time found leisure to observe the scene around, and to search for the form that had drawn her hither.

Thomas Hardy

CORSETS IN SWANAGE

A job which was more to my liking, and which I kept for several years until leaving school, was the first one I obtained for myself, as distinct from being sent to report at a parent's orders. It was in a draper's shop, and still meant that all my waking hours were occupied; but it was out of doors, and I could run with the best and fastest errand-boy in the town. In the barber's shop the surroundings had been entirely masculine, where I learnt what men did, thought and wanted; and while I am still very grateful for the eduction it provided me with, which would have been unobtainable elsewhere, it would never have provided me with the equivalent insight to what the other sex also did, thought and wanted. I might have grown up with a very one-sided view of life. The draper's shop supplied the balance. It was owned and staffed by women and girls, the customers were women, the whole stock was feminine,

GARSTIN BRIDGE

and I was the only male with unobtrusive entry there. They probably looked on a small boy as a neuter.

In a way it was soothingly exciting to deal entirely with women, and the loving care they had for clothes was something quite new to me. I was learning that they wanted their clothes to express their bodies. To me clothes had been a means of keeping warm, and, above all, something to cover the body from other people's eyes. I was to learn that a woman wanted her clothes to call attention to her bodily attractions, real or imagined, and it was bound to interest me, straight from a barber's chair, where clothes were often thick and bulky, and could be anything but attractive to wear. In the show-rooms I occasionally caught a glimpse of more than I should—not only did ladies try on new hats; they sometimes showed long, thrilling lengths of leg, with all the trimmings that in those days went with them. Perhaps it was no wonder that a small boy began laying the foundations of a long admiration of the female form. There was always someone new to fall for, each few days supplied some new ideal of what women could be.

The main work seemed to be delivering parcels of corsets on approval and then calling for the 'returns' in a few days. The parcel was delivered neatly wrapped up and tied firmly; but nine times out of ten it was collected with both ends open and the suspenders hanging out in the air—probably the string was kept to tie up pudding-basins. If any man does not quite see the connection between those ladies' corsets and suspenders, I might tell him that in those days there seemed to be a bunch of suspenders hanging from them, perhaps from both ends, as they always dangled out of both ends of the parcel. Modern days may have evolved some neater arrangement. Once it would have embarrassed me to carry such an intimate parcel through the street, but there again it was being proved to me that a worker can get used to almost anything, even corsets. It was interesting to notice the sort of woman who would hand out a parcel like that. She might come to the door all prinked up, and scorn to have a spot on the doorstep or smudge on the window curtains; but she did not mind a boy walking out of her gate with corsets hanging out of both ends of the parcel.

According to all the rules, I should have seen enough of women to expose them for what some men say they are, yet on the whole I developed a good opinion of them, although I soon found out that they seemed constitutionally incapable of comradeship as understood by the men in the barber's shop. But when one woman let me down badly, it did not make me a life-long hater of women, as it might have done. Anyway, some men explain their

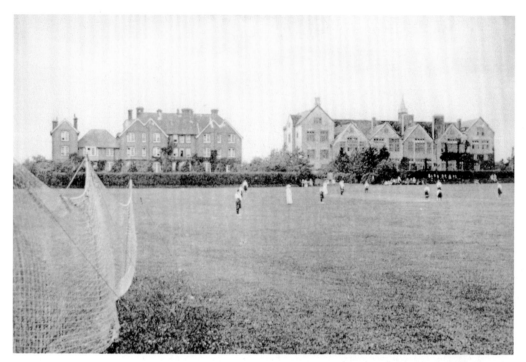

CRICKET, LADIES' COLLEGE, SHERBORNE

non-contact with women for less than how one treated me. Every so often there was a consignment of advertising handbills to distribute, and it was easy enough to get rid of a lot by leaving one at each house when delivering a parcel, but in the cubby-hole where the parcels were stacked for delivery there would be thousands and thousands of handbills waiting for me to annoy the town with. Naturally I neglected them as much as possible, until someone noticed it and sent me off with an armful.

It may seem easy to just hand round a few handbills. You just push them at people and in door-cracks, and there you are. But when they are good-sized leaflets, with perhaps a sample of material gummed inside, it is not so easy. One cold winter day I was sent along the sea-front with an armful, and I knew very well that I had saturated all the houses out that way with those particular bills—a row of houses will absorb them only to a certain extent; after that it can be almost dangerous to be found slipping one through the letter-box. In the summer, when the beach was crowded, it was possible to get rid of almost unlimited amounts there. Groups of people lying about might wave me aside, but not before I gave them one each, and perhaps two to the children. I might get horribly threatened by some man dozing in a deck chair who was disturbed to receive a picture of a pretty girl dressed in somebody's well-fitting corsets, but on the whole the beach was a good place to work along.

But the summer saturation standard of the beach was not available in the winter; there was not a person on it to receive my handbills; yet I made up my mind that the beach had to help, so I scooped a hole and buried some of them out of sight. Of course I looked round

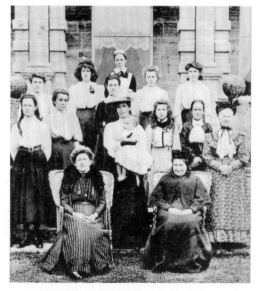

BUTTON WORKERS, SOUTH LYTCHETT

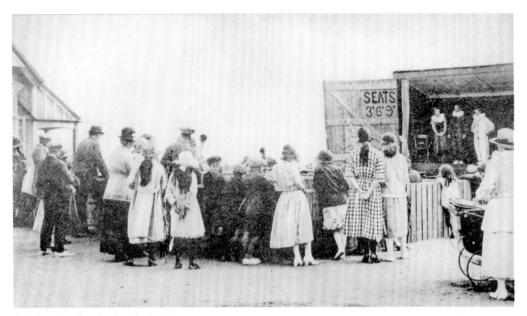

PIERROT TROUPE, WEST BAY

to see if anyone was about, but as Swanage sea-front could be very deserted on a cold winter day, there was only one woman in sight, and I took the risk. Yet as soon as I reached the shop again I was brought up on the carpet, and asked where I had delivered those confounded bills. In telling the truth there was no credit due to me, yet it was surprising how much was given; it seemed that to tell the truth outbalanced the value of the bills. Yet that was not all that was concerned; it seemed that, after all, no one admired that woman for reporting me. Later I proved that it really had been the woman I saw coming along the sea-front; yet even today it is beyond me why an unmarried young woman should go out of her way to get a boy in trouble about something not very important, and certainly not any of her concern. Luckily I was so made that one unfortunate encounter with an unsympathetic woman did not make me decide that they were all like that—at the time I thought that perhaps some man had wronged her.

There was one thing which I learnt while working in that shop, and that was that appearances did not always count. I might see a wonderful woman in the shop, with perhaps a daughter or two coming on, but of course still raw as compared with the mother, and later I would have to deliver a parcel to one of the local hotels. I had learnt that parcels for such people were not delivered to the slovenly back doors of such places but had to be handed in at the reception office. The mere handing in of the parcel was easy enough, but sometimes within a few days I was sent again with the bill, and told to wait for an answer. That again was easy enough, because of course I was told that the lady was not in, but equally of course I was sent again, and told not to leave until I did get an answer.

Now, it can be agreed that an hotel can be an easy place for a guest—things are supposed to go like clockwork and the staff may be more than helpful. But it was a very different thing for a boy trying to get in touch with a guest. The reception clerk tried to shelve the matter, and hoped the boy would lose heart and go away; the hall porter would move him aside every time a guest went to the office or even came near; more and more the boy would be conscious of his nailed boots marking the polished floor and his own general shabbiness in that atmosphere. Outside he might be able to run and whistle with the best, but inside the hotel he felt stifled.

More than once I went through that experience, but as it was my job to get some sort of an answer, I waited until the clerk realised that I would not go away. Then, as I expected, she would look through the register and copy an address to give me, and as most people understand that the addresses entered in a hotel register are not necessarily full, to say the least, it is not surprising that sometimes the address did not cheer them very much when I returned to the shop. It simply meant that one more splendid-looking lady had outfitted herself, and

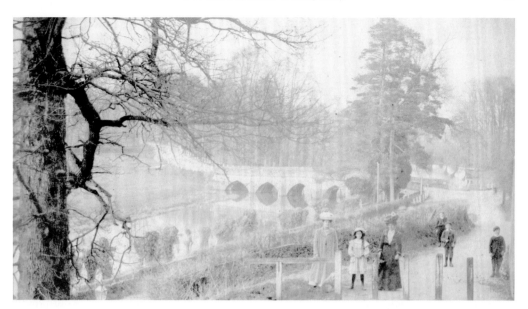

STURMINSTER NEWTON BRIDGE

perhaps daughters, with corsets from a small draper at the seaside. It was fair game, perhaps, and of course may be legitimate, because she scrawled some sort of address in the register; but what surprised me was that the hotel staff did everything they could to prevent me obtaining even that. To my innocent and inexperienced mind they should have been just as shocked as I was, and just as anxious to get on the trail. But I was learning that grand-looking-people who stayed at expensive hotels might be glad to pick up their corsets where they could.

Eric Benfield

THE ISLAND OF PORTLAND

What a wealth of romance has surrounded this West Country promontory since the days of my earliest childhood! Its frowning forehead was familiar to me from Brunswick Terrace in Weymouth, towering above the magpie-speckled lighthouse on the 'old' Breakwater. Rumours of it had reached my ears when I was a very infant. My father used often to appear with round flat pebbles for my mother and grandmother to paint pictures upon, and these, I was told, came from Portland; and when the weather had been particularly wild I would hear of my father and my elder brothers making an excursion to Portland to see the waves!

I cannot conceive of any portion of the English coast more calculated to arouse a boy's imagination than the Chiswell end of the Chesil Beach. It is possible even when the weather is rough to stand in comparative safety and look down into the dragon throat of the terrible bay. A prodigious Atlantic roller, visible for a long time to a rain-drenched onlooker above the turbulence of all lesser waves far out at sea, dashes itself at last against this huge natural breakwater, and a second later, its pride broken, withdraws with an irresistible suction down, down, down, foam and tumbling pebbles together, until with a snarl, the very ocean floor is, for the duration of a moment, exposed under the curved suspended arch of a tottering wall of water, high towering as a church steeple, broad and awe-inspiring as the Niagara in flood.

On a fair summer's morning how wonderful to stand on the famous sea-bank looking out over Dead Man's Bay, with wide-benched deep-water fishing-boats on every side, and the pebbles under foot spotted and blackened with fisherman's tar; the air smelling of green waves, of wind and sunshine; and with vast nets spread out everywhere to dry, loaded with cork floats five times larger in size than those that dangle on the puny spider-web Weymouth nets, brown nets with a mesh so stout that they could drag to shore an entangled mermaid for all her petulance. And the old stone tavern called the Cove Inn which stands on the top of the beach—was there ever such a hostel? The landlord once told me that during the worst winter gales the sea invariably reaches to its stone

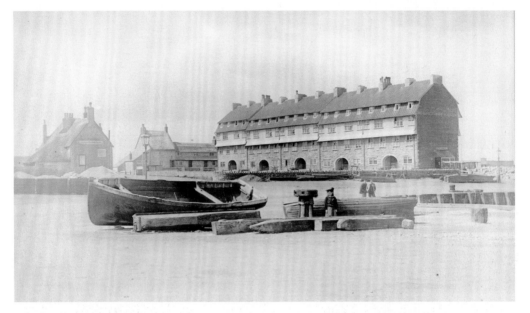

BEACH AND PIER TERRACE, WEST BAY

porch and goes pouring down on each side of the house to the sheltered village street below. What a view presents itself from its sarcophagus-like doorway in fine weather—the great sea beach with its wide-sweeping curve of twenty miles, the broad flecked acres of the West Bay; and everywhere old weatherworn benches, old stone seats, where generations of aged fishermen, with bleared eyes still as keen of sight as the eyes of shags are content to sit for hours scanning a sea and horizon familiar to them for the past seventy or eighty years.

Llewelyn Powys

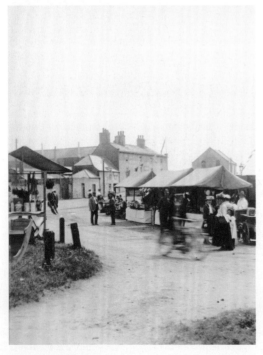

FAIR, WEST BAY

CHESIL BANK

Probably no part of the English coast has seen more numerous or more fatal wrecks than has the Chesil Bank. The numbers of lives lost here are to be counted by thousands, for it has been to the seaman a veritable beach of death. When the sea gives up her dead it will be a host uncountable who will crowd the steep sides of the amphitheatre of Deadman's Bay.

The great beach too is haunted by stories of wreckers, of ships lured ashore by misguiding lights, of drowning men murdered, of gasping sailors robbed and pushed back into the sea to die, of booty washed ashore, of awful revels when men drank from derelict spirit casks until they lay purple and dead on the pebbles. In the winter of 1748 *The Hope of Amsterdam* was wrecked on this lamentable strand with a cargo of £50,000 in gold. 'The shore then was a scene of unheard of riot, violence, and barbarity' A crowd swarmed about the water's edge grubbing for gold, tearing up the shingle with their nails, fighting over gleaming coins like starved wolves, and in the black of the night robbing and strangling men with

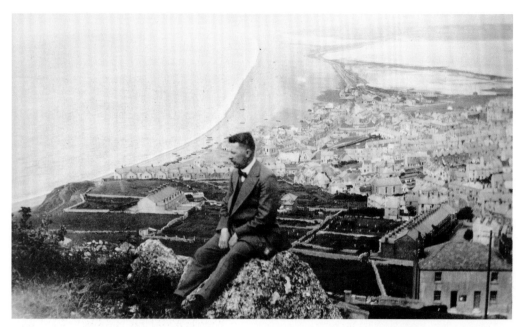

PORTLAND HEIGHTS

glutted pockets. For ten awful days the mob held the beach in defiance of the representatives of law and order, while the terrace of the Chesil Bank might have belonged to a circle in Dante's Purgatory.

Viewed on a calm summer's day from the heights above Abbotsbury, the Chesil Beach is but the gentlest, sleepiest curve of fawn-coloured shingle, lying lazily between the blue waters of the Fleet and the line of white foam on the margin of the treacherous bay.

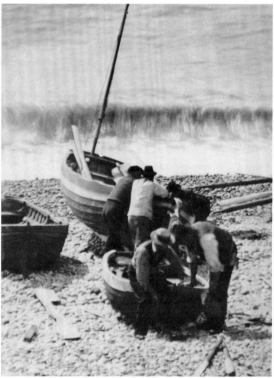

One curious feature of the Bank is the very regular manner in which the pebbles diminish in size from Portland to Burton. So definite is this that a local fisherman landing upon the beach at night can tell from the size of the stones at what particular point he has come ashore. This index, it is said, was of much service to the uncertain smuggler who was bringing his goods to land in the dark. The reason for the diminishing scale in stones depends upon the wind rather than the tide. The shore is very fully exposed to the west wind, but is sheltered from the east. The west is the stronger breeze, and carries, by means of the waves it makes, the larger pebbles eastwards, so that the stones of greater size are to be found under the shelter of Portland. Thus it comes about that the note of the beach varies in its course, changing from the whisper of sand to the hissing of shingle and then to the hollow rattling and rumbling of down-dragged pebbles.

Sir Frederick Treves

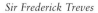

BOATS ON CHESIL BEACH

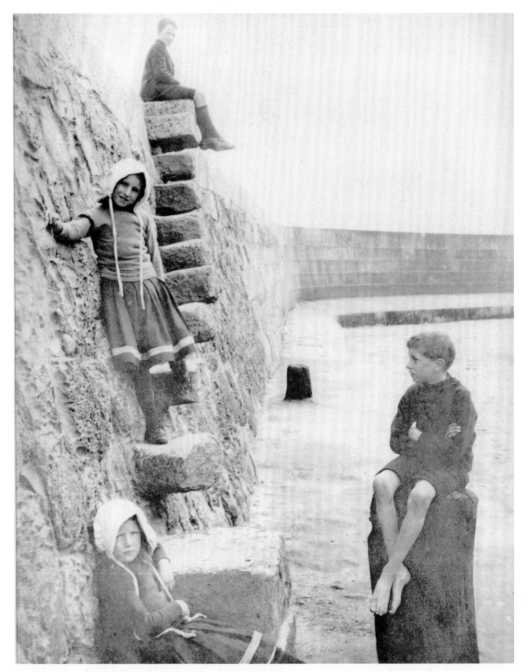

THE DRAGON'S TEETH, LYME REGIS

A COMMONWEALTH OF CHILDREN—A REMARKABLE INSTITUTION IN DORSET

A start has been made with the practical working of the Children's Commonwealth at Batcombe, a hill village in Mid-Dorset. At present the 'citizens' number only nine, four girls and five boys, nearly all of whom belong to London, but more boys are expected in a day or two. Before the year ends and when the cottages are all ready the population will reach 40. The commonwealth will be under the control of an executive committee in London of which Mr George Montagu the chairman, and the local superintendent is Mr Homer Lane, an American, who was for eight years superintendent of the juvenile republic at Detroit.

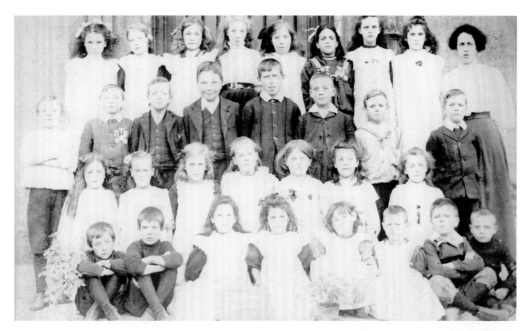

COUNCIL SCHOOL, SHERBORNE

The 'citizens' are now working with energy in clearing and improving the place, preparing to make roads, &c., and one boy, 'Citizen Harry', is in charge of the water pumping station. No rules have yet been made for the working of the little republic, and no rules will be made except by the citizens themselves, the object being to develop the sense of responsibility and community of interest. Mr George Montagu, who is a member of the Borstal Committee, and has taken the initiative in the movement, is very hopeful of results, and his uncle, the Earl of Sandwich, who has given a lease of the farm for 21 years, is also keenly and sympathetically interested in the experiment.

The central 'seat of government', Flower's Farmhouse, is a roomy house built substantially of stone in 1888 by the Paulett family, whose familiar arms, three swords with their points meeting, are sculptured on a stone escutcheon in the front. The clink of bricklayers' trowels drew attention to red-brick walls rising within a skeleton of scaffold poles a short distance to the west of the farmhouse, a notice-board announcing the builder and contractor as Mr R. G. Spiller of Sherborne and Chard. These are the first two cottages which are being built to supplement the accommodation of the present farm-house. The area of land to be occupied by the settlement is nearly 190 acres.

Already the teaching of carpentry has been begun under Mr Lane, and other crafts will be taught in due course, and there will be laundries for the girl citizens to work in. A large barn will be turned into a big assembly-room. The citizens will be under the care of instructors and house mothers. The Commonwealth is not yet certified by the Home Office. At present boys and girls come by a voluntary arrangement with their parents, who are given the option of saying whether they would like their children to come here or, as the alternative, go to a reformatory school.

'There will be plenty of work to do,' said Mr Montagu, in an interview, 'making roads and drains. Later on the citizens will do their own building. Then we have to put in our own water supply, and to instal also a permanent system for the supply of the village of Batcombe. The water is obtained from springs under the chalk hills. For our temporary supply we have a catch basin made down in the spinney. We have erected an engine and a pump there, and laid a temporary main to a tank in the house, with a capacity of 600 gallons. The pumping engine is of three-horse-power, driven by petrol. Engine and plant are now entirely under the charge of a 14-year-old boy, 'Engineer Harry'. Later on we propose to instal a large engine, of six or eight horse-power, to construct a reservoir with a capacity of 15,000 gallons, and to connect up every building in the village.'

'The idea,' added Mr Homer Lane, 'is to give the boys and girls definite responsibility, and to encourage them to perfect themselves in it:

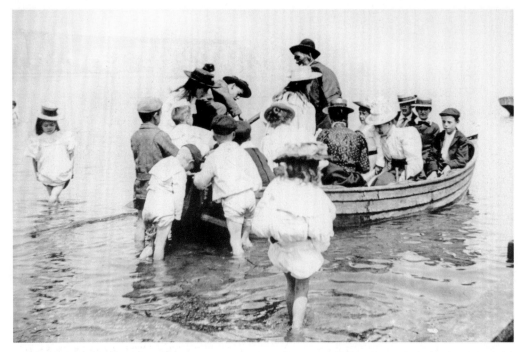

SUNDAY SCHOOL TRIP, SWANAGE

'As to the government of the place,' said Mr Lane, 'upon the citizens themselves is laid the responsibility of legislation. As necessity arises, and experience dictates, they will make rules and laws and enforce them for the good of the community. Whenever anything happens which seems to indicate something wrong, and different interests clash, a meeting will be held, the matter will be discussed, and the majority will settle it:

With regard to the routine, breakfast is at 7.30. The stable boys have their horses to attend to before breakfast; meanwhile the girls have to sweep and dust, and those in charge of the kitchen, start their day's work. Dinner is served at twelve, tea at five, and a light supper at eight. Nine or 9.30 is the hour for retiring. From tea till supper is time for recreation and amusement, when the day's work is done.

Western Gazette, 2 August 1913

HIGHWAYS AND BYWAYS IN DORSET

In Domesday Book the town was called Swanwic, which name it long retained, for in the reign of Henry II it is recorded that 'the men of Roger de Poles of Swanwich answered half a mark for seising wronfully a great or royal fish.' Swanage, as I knew it some thirty-five years ago, was a queer little town with a rambling High Street and a jumble of picturesque cottages of Purbeck stone, whose rough roofs were much given to gable ends and dormer windows. In those days it could still claim to be the 'quaint, old-world village' that Charles Kingsley loved. Now it is the scene of a feverish struggle between rival builders, who fight to cover the land with copious red brick in as little time as possible. What can be done to spoil a characteristic village the founders of Swanage the Up-to-Date have done. The curve of the sandy bay is swept by a long brick coalshed, and is palisaded by the unlovely backs of unashamed houses. It only needs a gasometer on the beach to complete the sorry *renaissance*. Old Swanage has gone; the features which made it unique among the Southern sea towns have been swept away, so that in a few more years it will be indistinguishable from the host of 'developed' red-brick coast resorts on the shores of England. Its stretch of sand, its blue bay, its rolling downs, and its healthy site are still happily left to it.

Swanage devotes itself body and soul to a hearty multitude called by the townfolk 'the steamer people' and by the less tolerant 'the trippers'. They come to old Leland's 'fishar towne' in their thousands, so that in August the beach is as jolly' and as 'ripping' as Hampstead Heath in holiday time. Probably none in these islands deserve a

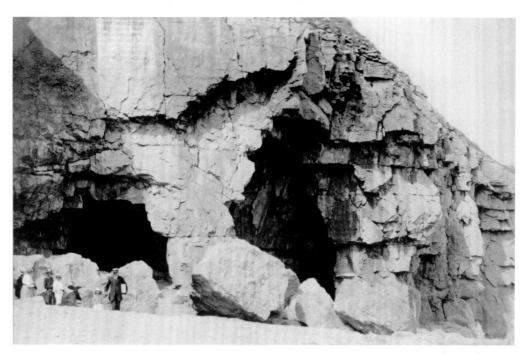

TILLY WHIM CAVES, SWANAGE

holiday more thoroughly than do the 'steamer people', for when they are not 'tripping' they are busy with every kind of useful work. None enjoy a holiday so well. If they are a little overexuberant, a little destructive and untidy, and if they have caused the land to be planted with notices that 'Trespassers will be Prosecuted', their untrammelled enjoyment must excuse much.

For the delectation of the steamer people Swanage has made most liberal provision. On the cliff's edge is Durlston Castle, a stronghold of the Bank Holiday period, in which is combined the architectural features of a refreshment buffet, a tram terminus, and a Norman keep. Close to this is Tilly Whim, reputed to be a smugglers' cave, but in plain fact a disused quarry. It is approached by a dark, sloping tunnel, in the descent of which the women scream, while the men support them copiously. Every available surface in this smugglers' haunt is carved with the names or initials of steamer people, while the ground is littered with their bottles, their egg-shells, and their paper bags. The enterprising developer of the estate about Tilly Whim has a fine literary taste. He has named every stone seat after some famous poet, and has engraved in many places improving sentiments upon slabs of local marble. Thus, in one spot he implores the steamer people to 'Look round, and read Great Nature's open Book', while in the cave, where the quarrymen fashioned kitchen sinks, he breaks out into Shakespeare in the following depressing strain:

> The cloud capp'd towers, the gorgeous palaces,
> The solemn temples, the great globe itself,
> Yea, all which it inherit, shall dissolve;
> And, like the baseless fabric of a vision,
> Leave not a rack behind.

Sir Frederick Treves

LODMOOR MARSHES

Lodmoor was a place which seemed to us fraught with romance. Perhaps it had once been the estuary of some forgotten river, perhaps it had merely been an arm of the sea. It was encircled by low hills, on which were fir plantations and copses and here and there a farm-house. The broad flats were intersected by waterways, and their brackish grass fed a few sheep which had to be watched and sometimes rescued from the muddy ditches.

THE CHURCH BEFORE RESTORATION, STRATTON

French butchers would have made capital of such prés salés but I never heard such mutton advertised and local predilection would certainly have turned to the small sheep of Portland. In the strong heats of summer a shimmering haze often wrapped the flats in mystery, and in the winter it was the first place to freeze. Then all younger Weymouth went out to skate, there were barrows of buns and apples and ginger-beer, there were no treacherous depths to fear and everyone enjoyed themselves amazingly till early night fell. Weymouth, to tell the truth, was never a great skating place, a mild proficiency went a long way because hard winters were rare in so favoured a spot.

THE HUNT

After night fell wilder spirits roamed Lodmoor. Perhaps sporting rights did not run on so lonely a spot, and if there were rights they were not observed. Everyone with a gun and a taste for letting it off knew Lodmoor. If he had a dog as well then all the better. My uncle John had known the fascination of the spot, had braved his father's strong disapproval of such 'poaching' when he was a boy at home, and afterwards renewed his sporting memories when he came down from London for a holiday. He often talked of Lodmoor and had tales of heron and other much stranger birds which were perhaps the outcome of a younger fancy. Yet I have seen heron there myself, and swans from Abbotsbury: and my brother Bob and I have found snipes' eggs and some which we set down to curlew though perhaps they were not.

The great hierophants and exponents of Lodmoor sporting were a remarkable family called Knight. There were four or more great sons, tall lank men, with striking faces and marked and well-moulded

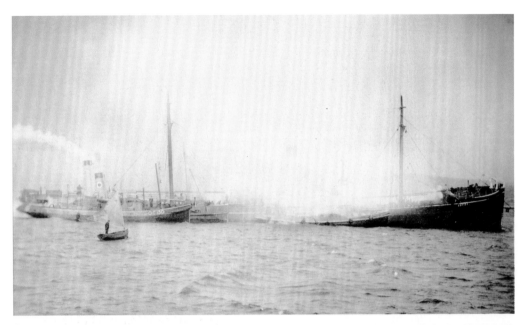

SS *SANDAL* ON FIRE, PORTLAND HARBOUR

noses. There was something about them quite different to anyone else, they seemed to form a separate class. They were solemn men with faces which seemed sunburnt with suns that had set long ago, it may be that there was gipsy blood in their veins. Their father was such a man as his sons, tall and lean, and his name was Emmanuel. By day they were wheel-chairmen, taciturn and well-behaved. My aunts employed them as chairmen and in many other capacities such as carpet-beaters or porters finding them always well-ordered intelligent and trustworthy. By night these thin strong-built men had a reputation for 'wildness', which was nearer defined as poaching and dealing with the contraband. I have no means of judging what truth there was in such stories, they were kind to me as a boy and so I liked them. The son that I knew best was also called Emmanuel and once he offered to take me to Lodmoor, for 'flight-shooting' when a winter evening fell. I don't know why I did not go, perhaps it was a coward's misgiving of the darkness and loneliness and the tall and silent strong-man, perhaps there was too a feeling that when the 'sport' was over I should be expected to offer him some 'tip', and I had no money. I dare say that some of the Knights still survive. If they do they must now be old men, but I wish them well for kindly sportsmen; where there was a Knight there was never lacking a dog and a gun. In winter-time, especially when it was near Guy Faux' day, and I was staying with my aunts as a little boy, my aunt Ellen would take me down to town to buy 2/- worth of fireworks. These were let off in front of the dining-room bow-window and as I was supposed to be too young to do it entirely unassisted, Emmanuel (called Manuel for short) was called to supervise. My aunts all stood to watch through the window and aunt Lot who had a very horror of all pyrotechnics used to delight me by giving quite genuine screams at anything that banged.

John Meade Falkner

THE COLLISION OFF PORTLAND

The English Channel was on Tuesday night, the 11th instant, the scene of one of the direst calamities that have happened in our time, sad though the catalogue has been of collisions and wrecks along this much frequented highway of maritime commerce. On this night, two fine ships, the *Avalanche* and the *Forest*, came into collision, and the result was the loss of 108 lives, of whom nearly 100 went down with the former vessel almost in an instant. It will be seen by our reports that the *Avalanche* was bound from London to New Zealand with 63 passengers and a crew of 36; the *Forest* was outward bound from London, in ballast, and had a crew of 20, but no passengers. Of the whole number of human beings in both vessels only twelve are known to have been saved. According to

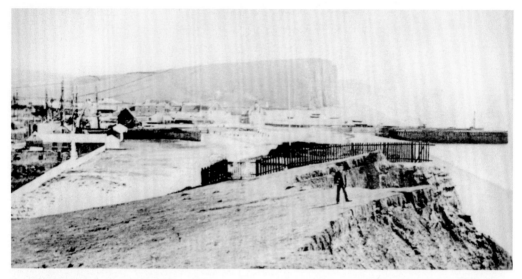

WEST BAY

the accounts which have been received, and the evidence of the survivors taken before the Coroner's court, the following seem to be briefly the leading circumstances attending the disaster:- The two vessels were proceeding out of the Channel, the *Avalanche* being on the port, and the *Forest* on the starboard tack. The former was evidently slightly ahead, and being on the port tack she ought, according to the rule of the road at sea, to have given way directly she sighted the *Forest*. As, however, she held on her course without tacking, it is but fair to assume that the near approach of the *Forest* was not perceived. It then became the duty of the *Forest* to keep clear; and the master, Captain Lockhart, asserts that, seeing the risk of collision, he ordered the helm to be luffed, and that his order was carried out. But it was too late, for before his ship could be brought head on to the wind she ran with terrific violence right against the side of the *Avalanche* amidships, and as she rebounded struck her twice again in the stern.

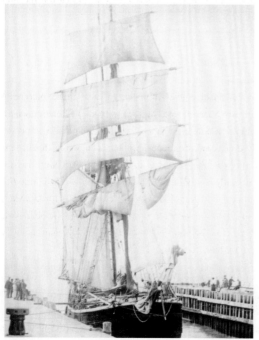

WEST BAY

Almost instantaneously the *Avalanche* filled and sank. A few of her crew managed to scramble on board the *Forest*, and three of them were subsequently saved. But so quickly did the *Avalanche* founder that there was no time to launch the boats, and all her passengers, and almost all her crew, including the pilot in charge of the ship, went down before they could make even an effort to save themselves. Those on board the *Forest* were scarcely in better plight. A few minutes after the collision it became clear that the vessel was sinking, and Captain Lockhart accordingly ordered the boats to be got ready. Three of them were launched at once and boarded by the crew of the *Forest* and the survivors of the *Avalanche*. But only one boat came safely to land, and her crew of 12 persons represent all who were saved out of 120 souls on board the two vessels. The *Forest* capsized about an hour after being abandoned, and has been passed floating bottom upwards a few miles off Portland. As in other cases of this kind, there will be a searching investigation, but, judging from past experience, it is questionable whether a result will be arrived at such as would render these terrible collisions

DEDICATION OF WILLIAM BARNES STATUE, DORCHESTER

practically impossible. The time has, however, come when some energetic action should be taken towards this end. We know full well that the night of the 11th was black with storm clouds, with a fierce wind, and a sea running "mountains high"; but many such nights are inevitable every year, and the question is, can nothing be done to successfully cope with the risks contingent upon such weather. A writer in the *Graphic* suggests that, during the short Channel voyage, ships and steamers should be provided with lights of far greater power and brilliancy than those now used, so that any two vessels approaching one another may have more time to give each other a wide berth. We are not in a position to judge of the practicability of this plan, but no doubt it might be fairly considered. England, as the first maritime nation in the world, ought to leave nothing undone that would ensure the safe navigation of the seas which immediately surround her coasts.

The Poole Herald, 20 September 1877

WILLIAM BARNES' LAST DAYS

The bard of Dorset died in 1886, at the age of eighty-five. Mr Gosse gives, in a letter, a very graphic picture of the last days of this remarkable old man. 'Hardy and I went on Monday last,' he writes, 'to Came Rectory, where he [the poet] lies bedridden. It is curious that he is dying as picturesquely as he lived. We found him in bed in his study, his face turned to the window, where the light came streaming in through flowering plants, his brown books on all sides of him save one, the wall behind him being hung with old green tapestry. He had a scarlet bedgown on, a kind of soft biretta of dark red wool on his head, from which his long white hair escaped on to the pillow; his grey beard, grown very long, upon his breast; his complexion, which you recollect as richly bronzed, has become blanched by keeping indoors, and is now waxily white where it is not waxily pink; the blue eyes, half shut, restless under languid lids. I wish I could paint for you the strange effect of this old, old man, lying in cardinal scarlet in his white bed, the only bright spot in the gloom of all these books.

Sir Frederick Treves

DIARY OF WYNNE ALBERT BANKS 1840–1912

1 November 1878: Our 'Teetotal' cook to our great joy gave warning, she got gloriously drunk when we had people to dinner and Bishop our butler told her she must give warning or he would tell us about her being drunk and she would be instantly discharged.

OPENING CHURCH HOUSE, WIMBORNE

1 July 1880: From 2 to 6.30 trying the most difficult case I ever had before me. Four people implicated in coining and passing money. 1) The coiner 2) The man who took it to Upway station 3) The woman who received it at Upway station and 4) The man who passed the bad money at various public houses and shops. The coiner was defended and the others were not so I had to watch the cases for the undefended and to sum up separately though the prisoners were all tried together and then given separate sentences, but I got through the whole case satisfactorily.

15 August 1883: At Studland for the Church Bazaar in a large tent in the pony field. About 200 people came and we made about £76. The second day well attended by the village people. Gross takings for both days about £120 nett after paying expenses. £100 towards the repair of Studland Church.

10 October 1883: Our Grand Bazaar for the County Museum fund—we opened at 2 and the public came in at once. 2/6 entrance until 5pm. Closed at 9pm. We took about £250 at the stalls—Gertis Vie, May Digby, Charlotte Grove, Mrs Helyar all helping Florrie to sell.

4 February 1889: The Barnes Statue unveiled by the Bishop of Salisbury. I returned thanks for the Committee. The statue in bronze of the Dorset poet Barnes is a very great success and the likeness excellent.

Wynne Albert Banks

COUNTRY MUSIC

On one of those cold winter days when the sun shone so brightly that in a sheltered spot it was easy to imagine that winter was passing, I saw a black smoke-funnel standing beside some cornricks. The thrasher had come to a farm where they did not carry the corn to the rickyard, but stacked it out on the hillside. And as it was midday, there was no movement there except the thin plume of smoke hurrying out of the smoke-funnel and stray straws which lifted fretfully but lacked the power behind them to blow out into the world. The thrasher crew were taking their midday meal, and the machine was still; probably they were indifferent then to the god that machinery has become since, as it was many years ago, and also it was in Purbeck.

I guessed that the men were sitting on the south side of the rick in the sun and out of the wind, but I approached from behind, with the idea of first seeing if there was a man there who might greet me. Perhaps it may be thought that I was carrying diffidence too far, and that such men would not object to a boy waiting to see them start work again; but in those days I belonged entirely to the quarrying part of Purbeck, and did not have the confidence to

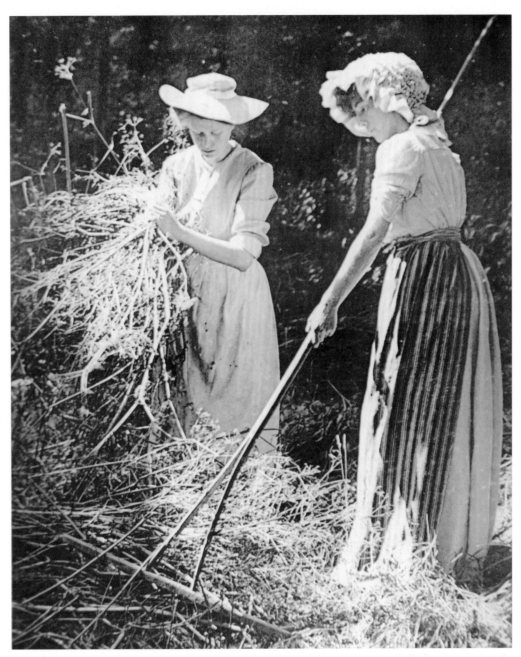

GIRLS HAYMAKING

gate-crash into the green country devoted to farming. It was quite possible that the thrashing crew would give me cold looks, even if they did not tell me to clear off. So I approached from behind, and passed near the great traction engine, which breathed with little warm sounds, and when I was ready to look round the corner, I heard the sound of music such as I had never heard before.

At first it seemed as if it was very far away, and then that it came from inside the rick and might be the screaming of mice who were aware that their home was soon to be scattered. But it was music. It ran up and up as if it would escape into the sky; but there was always another musician to come in and keep the tiny air going. That was the strangest thing about it—it was tiny, it was small enough to be played by a band of mice, and I was young and foolish enough to think of fairies. There were the little warm sounds from the engine and the occasional rasping

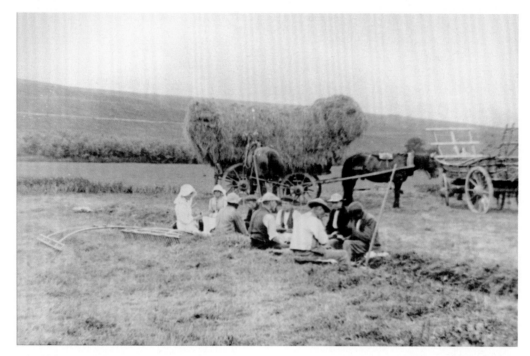

HAYMAKERS' BREAK

of straws in the wind; but it seemed that there were no other humans anywhere near. I really looked around near my feet and grew excited in case I was going to meet the little people in whom I had no real belief.

Naturally I discovered no fairies, and soon realised that the music was coming from around the corner, and also remembered that there must be six or so men around there sitting in the straw. Even then I had no idea that they were the musicians, but I was still less likely to break in on them while they were being entertained by something right outside anything I knew about. More than half afraid, I edged out until the men came in sight, and they were the musicians. Each man blew into a tiny fragile pipe made from the biggest and best straws. Six grown men sat in the straw and produced a shrill music which seemed to jump all over the place, although there was always one coming in to start all over again.

I forgot that I might not be welcomed, nor did they take the slightest notice of me. I had expected fairies, and found six thrasher men. But their pipes were fairy pipes, and their music must have been handed down from some more magical age. I drew near with the feeling that there was no physical reason why I should not run up and down a stem of straw without breaking it. Fairies did not appear hurrying across the bare field, and not even a rabbit or a bird drew near to listen in wonder; but the spirit of the corn was there, and seemed not to be shy to sit in the light of the sun.

Perhaps it was only the breeze round the corner and a fascinated boy drawn out of his own shy, thinking, and therefore uneasy self; but that does not explain those six men. A little earlier they had eaten very material bread and cheese, and perhaps a bit of dead animal, probably washed down by cold tea or beer. They were all damp with sweat underneath, despite the cold day; they were dusty and dirty, and several of them had been sleeping with their wives in the early hours of the day. One of them was a very sick man who would work until the last possible day; another was little better than a half wit, while the smallest man of them all had recently done time for mean and very unromantic offences.

They were a typical thrasher crew—mostly men well past their prime, and glad to have some casual land work; but while they played that tiny shrill air on their straw pipes they were not only themselves, they were kindred of the life force that had caused the corn to grow and ripen in the field where they sat; their music belonged down amongst the field-tracks of all the small things which ran between the stalks. If music has anything more than an accident for a beginning, it certainly developed from the first breathings into a dried grass-stalk.

Eric Benfield

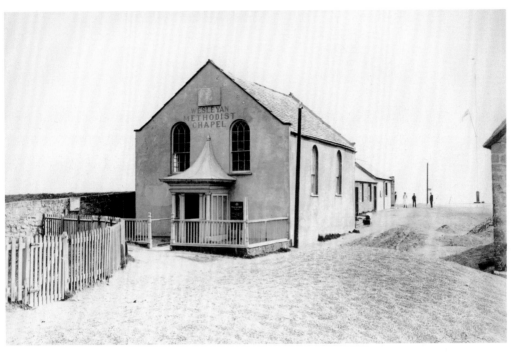

WESLEYAN METHODIST CHAPEL, WEST BAY

A SONG FOR THE MEN OF BRIDPORT

I likes the smell of dirt,
 It seems to do me good;
It raises up my spirits
 And relishes my food.

A dung-hill at my door
 And a cess-pool close at hand
Is the healthiest things in nature,
 The sweetest in the land.

'Tis nice to see my children
 Sitting down in filth and mire,
And their clothes in dirty patches
 Is all I could desire.

A shilling and three-halfpence
 I likes to pay for pills;
'Tis nicer and 'tis better
 Than giving up the 'smills'.

For water in my house
 Flowing nicely from a tap,
Pure, clean, and bright, and sparkling,
 I shouldn't care a rap.

I likes a great deal better
 To draw it from a well,
Looking yellow, tasting strongly,
 With a nice good drainy smell.

It makes the clothes look muddy,
 And the colour isn't good,
But it isn't bad in tea
 Or mixed up in my food.

Up then, ye men of Bridport!
 Get all the smells ye may:
For dirty courts and sickness,
 Hip, hip, hip, hip, Hurray!

Broadsheet, published by Prince, Printer and Stationer, Bridport

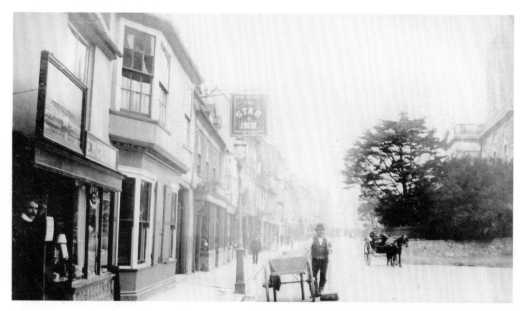

EAST STREET, BLANDFORD

FLIGHT FROM THE LAND

Another place that we visited was the seat of Lord Portman, a vast mansion situated at Bryanstone, near Blandford, where I had the pleasure of meeting Mr James Forrester, the agent. Here, as might be expected, everything is managed without thought of cost. Never before have I seen such buildings or cottages: the very cows are provided with softer sorts of wood on which to kneel, and the electric-light machinery reminds the visitor of the engines of some great ship. Mr Forrester said that the corn and sheep farms had depreciated 50 per cent. in value, but the grass land only 10 or 15 per cent. On that estate they had about 1,800 acres in hand. The tenants complained much of the labour, and their own case was little better. The young men went away continually. 'Please, sir, give me a character,' was the daily cry. The cottages upon the property were plentiful and good,

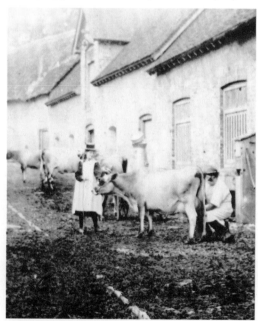

MILKING, WEST STAFFORD

and never had less than three bedrooms, two of them with fireplaces. The tenure of these cottages used to be quarterly, but of late, owing to the frequency of strikes amongst the labourers, they had been let subject to a weekly notice.

In addition to their model cottages, for which they pay very little—but 1s. 6d. a week—the labourers have pensions, clothing, and coal clubs, to which the subscriptions are doubled at the end of the year, liberal allowances in the case of sickness, allotments, and every conceivable advantage. They are well paid also, up to 18s. a week, with fuel for carters. Yet they go, and, what is more, strike at hay-time or other inconvenient seasons, and are generally troublesome. 'They won't be kept,' said Mr Forrester, but, male and female, depart, mostly to take service in shops. Few except the 'doodles' remain. Doodle, by the way, is the Dorsetshire equivalent for the Norfolk 'waster' and the Devonshire 'smike: Yet if they will not stop on an estate like this, which, of course, is run absolutely

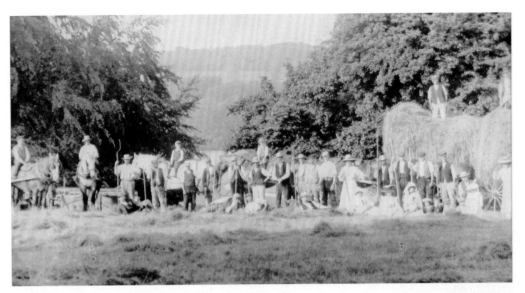

HAYMAKERS

without reference to expense—£10,000 a year, I understand, being spent in wages alone—where will they stop?

Everything has been tried. Thus, when some men asked for land, M. Forrester arranged for them to have a field of twenty-three acres, which was let at 24s. the acre, the landlord building a barn and providing a hand-power thrashing-machine. Fourteen men hired lots in this field, but in ten years there was only one of them left, the balance of the land having been rented by a miller. Again, cottages were sold to certain of the people upon special arrangements as to price. Mr Forrester said that this was the worst thing that ever happened to them, and some of these cottages were now being condemned because their occupiers had reduced them to such a condition that they were no longer fit for folk to live in. Mr Forrester seemed to think that the want of religious feeling that is so marked a symptom of the day, had much to do with the discontent of these people at the conditions of their life. Lack of principle was the root of it; also on that particular property there might have been some over-pampering.

H. Rider Haggard

CAUTION TO SWANAGE EXCURSIONISTS

To the Editor of the Poole Sun—For the benefit and information of persons visiting in the neighbourhood of Swanage, I beg to submit for publication in your paper the following facts:

Last Thursday, I and a friend were residing at Poole, and we took the excursion boat *Royal Albert* to Swanage.— Proceeding through the main thoroughfare at that place, we observed a sign-post outside one of the houses with the words 'The New Inn', by J. Hibbs. We entered for the purpose of getting two glasses of ale, when we were called into a front room by a person who appeared to be a great authority in the place; in fact, we took him to be the landlord, especially as he was sitting on the table. He appeared to have been drinking and wanted to be very familiar, asked us where we were going (to which we replied—Corfe Castle), and he wanted to pay for the ale, which had by this time arrived, but which kind (?) offer I declined—and asked him how far it was to Corfe Castle, to which he replied—7 miles, and suggested that we should ride there. He asked for a piece of paper on which he wrote

Mr Chas. Summers,
Posting Master,
Somerly House,
Near Albert Memorial

and said if we went there we could get a conveyance. 'I said yes, but that will cost us five shillings.' 'Oh!' he replied 'it's worth ten shillings to go there and back.' I asked him who I should say recommended me, when he

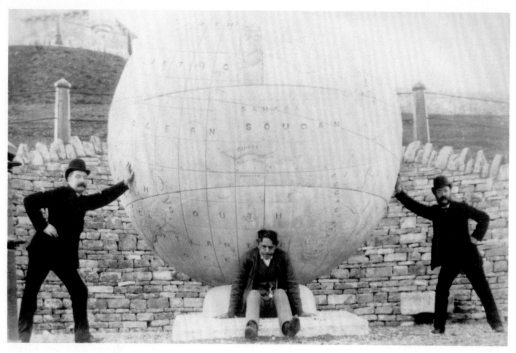

THE GLOBE, SWANAGE

wrote his initials—A. S.—at the bottom of the paper on which he had written the address and said his name was Stevens. I must confess I was somewhat surprised the next moment to hear the barmaid address him as Mr Summers, I said 'Oh, then you are Mr Summers,' and having made up my mind to walk to Corfe Castle, I expressed that intention—'Then a change came o'er the spirit of his dream.' He prevented me from leaving the room, took my high hat off, put it on his head and smashed it in at the top. He pulled me about and refused to return a book which, during the conversation, I had jokingly offered to sell him for ninepence and added to which he abused us right and left—wanted to lay £10 we couldn't muster up £3 10s between us. Of course I fetched the police who were exceedingly civil and willing, and ultimately the man paid me the value of the book—one shilling. Had I been staying at Poole for a day or so longer I should certainly have taken out a summons for the assault and unlawful detention of the book, but as I understood that the Court did not sit until Tuesday I was compelled to take a lenient view of the case. Trusting the above will be the means of preventing others from being similarly treated.—I enclose my card, and am

<div align="right">
Yours obediently,

A VICTIM
</div>

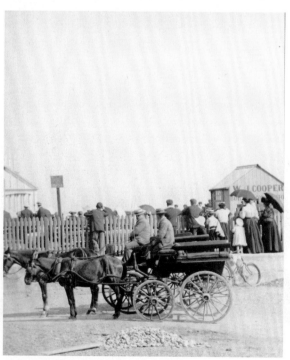

PIERROTS AT WEST BAY

The Poole Sun, 15 September 1877

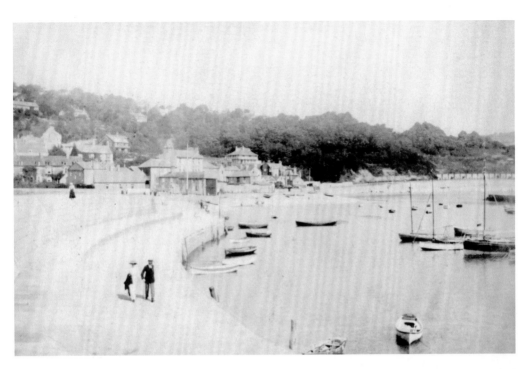

LYME REGIS

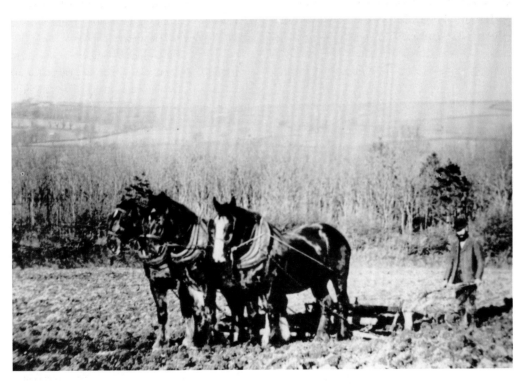

PLOUGHING, BRADFORD PEVERELL

BASHFUL BOY

HORSES, KINGSTON POND

A CARRIAGE ACCIDENT IN WEYMOUTH

A carriage, belonging to Mr Sheppard, came to grief on Wednesday afternoon. The vehicle was drawn by a young horse, and was left unattended for a minute or two at the Fox stables, when suddenly the horse started off and succeeded in rounding all corners safely until it came to the raised curb opposite the Crown Hotel. One of the fore wheels here came in contact with the stones and broke it to pieces, whilst the shock was so great that the horse got out of the traces and bolted down St Edmund Street, but stopped of its own accord near the Guildhall. Fortunately no one was injured by the accident.

Dorset County Chronicle and Somersetshire Gazette, 26 June 1873

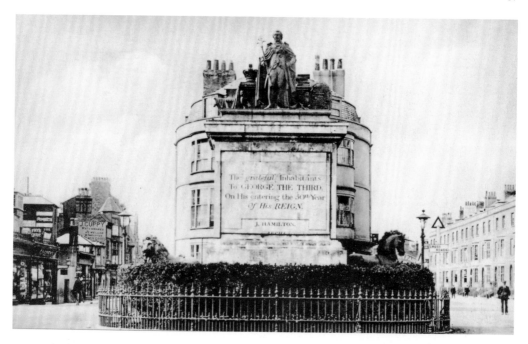

KING'S STATUE, WEYMOUTH

DANGERS OF THE CHANNEL

To the Editor of The Times—Sir,—Three years ago you were so kind as to insert a letter of mine in *The Times*, on the occasion of the wreck of the *Wild Wave*, on Peverill Ledge, near Swanage. One immediate result of that letter was the determination of the Trinity House authorities to set up a lighthouse on the cliffs between Swanage and St Aldhelm's Head, as advocated in your columns. The precise spot was forthwith carefully selected, the ground surveyed, complete plans prepared, and preliminary negotiations for the purchase of the site and approaches entered into, but nothing further has since been done. It is to push on this indispensable work, and to point out another requirement of the district, that I venture to trouble you again.

Late on the afternoon of the stormy day on which the *Forest* and the *Avalanche* came into collision, I was standing on a desolate rocky beach in this immediate neighbourhood, and not many miles away from the scene of that dreadful tragedy. Half a mile out at sea lay the wreck of a goodly vessel, the ship *Commodore*, of Carnarvon, stranded on Kimmeridge Ledges only a few days previously. Veritable avalanches of white water were breaking over her unlucky hull, while on the lurid horizon beyond, close-reefed vessels could be seen scudding uneasily before the gale, among them being, in all probabiliry, the two ships so soon to meet their doom.

Two years ago I visited the place to see the wreck of the fine German ship *Stralsund*, lost nearly on the same spot. About 18 years ago the Royal Mail steamer *Tyne* came to grief at the same place, and she lay there many months, and an enormous outlay and loss of property ensued. Since that period I am informed that something like 20 ships of different nationalities have been wrecked on these dangerous 'ledges', and the fishermen tell me they have seen two or three at a time.

Now, Sir, there can be little doubt that all this is remediable. Two things should be done. Firstly, Kimmeridge Ledges are not visible above water, and in fine weather there is no indication whatever of their existence. Their position should, therefore, be indicated in the usual way, by stationary buoys, placed at the proper distance out. Secondly, the new lighthouse on Anvil Point (the spot selected) would clear both Kimmeridge Ledges and St Aldhelm's race, the Scylla and Charybdis of these parts. There would then be no excuse for further loss of ships in this place either by night or day. People should realize the fact that nowadays ships sail along this great seaway by thousands, where in former times there were, in a descending scale, but hundreds or tens. It is certain that hair-breadth escapes, of which nothing is ever heard, are of daily occurrence.

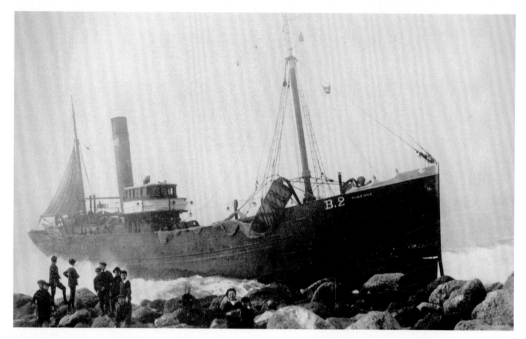

WRECK OF THE *TURENE*, PORTLAND

If you will allow me, I will, in conclusion, describe one such which has come to my knowledge. Not long ago a great ocean steamer, homeward bound, and crowded with passengers, when making her way for the Solent, was overtaken in the daytime by a fog when between Portland and St Aldhelm's Head. By some strange miscalculation the captain held on his way, and it led him, head on, nearly to the very spot where the Trinity House light is to be erected. For three miles on each side this spot there is a sheer cliff of Portland stone, 200 ft high, upright as the walls of a house, with no beach, and deep water up to its very base. By a merciful providence the fog lifted like the curtain of a theatre just as the ship, steaming on her way to destruction, was scarcely a cable's length from this stone wall! The appalling prospect was witnessed alike by captain, crew, and passengers. There was, however, just time to reverse the engines. Fortunately, the great ship answered her helm and with a shock which made her quiver from stem to stern, she was put 'about' and all was safe.

These facts were severally communicated to me by passengers who were on board—one of them an Admiral of the Fleet returning from Lisbon. Out of tenderness to the captain and officers of the ship, the occurrence was kept from public knowledge. But I send you, herewith, in confidence the name of the vessel and my informants.

Now, if the Anvil Point lighthouse had been erected, no ship could have run into this awful peril—by day the fog-horn would have sounded loud and clear for many a mile out to sea, while by night the piercing light would have sent its radiant beams far enough even into the thickest fog. On inquiry at Trinity House I have been informed that want of money is the cause of the delay in proceeding with this lighthouse. To ask how long this miserable plea is to weigh against the lives and fortunes of thousands is the main purport of this communication.

I am Sir, your obedient servant,

J. C. ROBINSON
Swanage.

The Times, 6 October 1877

SMUGGLING MEMORIES

It appeared that as a youth on a coast farm job Samways used to earn extra money by helping other enterprising lads to elude the Customs. The emoluments of a successful undertaking were considerable, the thankful glee of the smugglers sometimes taking the form of a convivial evening at a tavern, when watches were occasionally

CASTLE INN, WEST LULWORTH

fried to demonstrate the careless wealth of the owners. Kegs of spirits were frequently stored in a cave near White Nose Point, and it often fell to the lot of job to be lowered at night down the edge of the cliff, in order to attach a rope to the barrels, which were then drawn to the top. There they were packed into waggons, the wheels being muffled with felt, and carted inland.

On a certain dark night, the preventive men, as coastguards were then called, had been lured to another part of the coast, so that a cargo could be safely landed in a quiet creek two miles in the opposite direction. The smugglers descended to the shore, and each man took a keg and panted with it to the top of the slope. Before the journey was finished, however, a pistol shot rang out, the curtaining clouds fell away from the moon and disclosed a parry of advancing coastguards.

At this point in the narrative the old man invariably got excited, and his wife would say:

'Ah, dad, that brings us to your girt ingenity.'

Shots whizzed over young job's head, and presently one pierced his keg, and the liquor flowed. Anxious to save the precious liquid, he drew a cork from his pocket, bunged the hole, and succeeded in getting away with his valuable load!

'Lawk, to think of they times of strife and awfulness,' ejaculated Mary, dropping a stocking she always seemed to be knitting of an evening. 'Now tell us the bit about the chap who was shotted.'

But before the old man could get launched into this episode she frequently told the story herself, he nodding portentous approval from his corner. It told how the only son of a widow persisted in remaining a smuggler, in spite of his mother's anxious opposition. One day he hinted at an exploit in which he was interested, and this so incensed the woman that she thoughtlessly expressed a hope that he would be killed in the venture. On hearing this he walked into the garden, cut his name on a tree there standing, and led by a sense of impending doom, bought some white ribbon and flowers, which he gave to four girls, who wonderingly consented to walk at his funeral. The same night he was shot in an engagement with preventive men, the impulsive wish of the widow being thus fulfilled.

'And so it fell out to my good knowen,' the old man always added, when the story came to an end.

Wilkinson Sherren

VIEW FROM GREAT LANE, SHASTON

THE LEÄNE

They do zay that a travellen chap
 Have a-put in the newspeäper now,
That the bit o' green ground on the knap
 Should be all a-took in vor the plough.
He do fancy 'tis easy to show
 That we be but stunpolls at best,
Vor to leave a green spot where a flower can grow,
 Or a voot-weary walker mid rest.
'Tis hedge-grubben, Thomas, an' ledge-grubben,
 Never a-done
While a sov'ren mwore's to be won.

The road, he do zay, is so wide
 As 'tis wanted vor travellers' wheels,
As if all that did travel did ride
 An' did never get galls on their heels.
He would leave sich a thin strip o' groun',
 That, if a man's veet in his shoes
Wer a-burnen an' zore, why he coulden zit down
 But the wheels would run over his tooes.
Vor 'tis meake money, Thomas, an' teäke money.
 What's zwold an' bought
Is all that is worthy o' thought.

Years agoo the leäne-zides did bear grass,
 Vor to pull wi' the geeses' red bills,
That did hiss at the vo'k that did pass,
 Or the bwoys that pick'd up their white quills.
But shortly, if vower or vive
 Ov our goslens do creep vrom the agg,

They must mwope in the geärden, mwore dead then alive,
 In a coop, or a-tied by the lag.
Vor to catch at land, Thomas, an' snatch at land,
 Now is the plan;
Meake money wherever you can.

The children wull soon have noo pleäce
 Vor to play in, an' if they do grow,
They wull have a thin musheroom feäce,
 Wi' their bodies so sumple as dough.
But a man is a-meade ov a child,
 An' his limbs do grow worksome by play;
An' if the young child's little body's a-spweil'd,
 Why, the man's wull the sooner decay,
But wealth is wo'th now mwore than health is wo'th;
 Let it all goo,
If 't'ull bring but a sov'ren or two.

Vor to breed the young fox or the heare,
 We can gi'e up whole eacres o' ground,
But the greens be a-grudg'd, vor to rear,
 Our young children up healthy an' sound;
Why, there woon't be a-left the next age
 A green spot where their veet can goo free;
An' the goocoo wull soon be committed to cage
 Vor a trespass in aomebody's tree.
Vor 'tis locken up, Thomas, an' blocken up,
 Stranger or brother
Men mussen come nigh woone another.

William Barnes

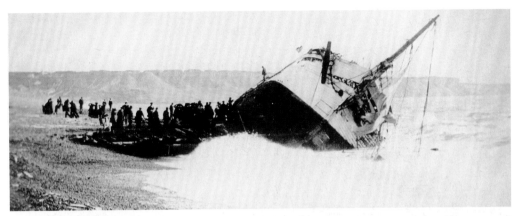

THE *EMMA MARIA* WRECKED, CHESIL BEACH

HELP ON THE HIGH SEAS

March 1872: A lot of ships came out of Portland roads and being heb tide and no wind they drifted all a long way by the shore and one Barque drifted as far as harry hillyers hope and being nearly shore she let go her anchor but drove and being so near the shore they could not let out more chain.

We launched our Boat Called the *Sarah Jane Ann* and whent up to her and the Captin asked us if we would carry of a small anchor and we said yes.

So we runed away the anchor and a warp and whent on board and hove her of and we a greed with the Captin to stay on board tell 5 o clock in the evening for the sum of £3 but the steamer came and thoead her away in Portland roads and we whent up in her. We had a plenty of beaf and bread and fried potatoes and good coffee. We had the boat up in roads and came back in her, had our money and went home. The Barque was called the *Daymer*. She was Americaen.

John Thomas Elliott

MOONFLEET BAY

Our village lies near the centre of Moonfleet Bay, a great bight twenty miles across, and a death-trap to up-channel sailors in a south-westerly gale. For with that wind blowing strong from south, if you cannot double the Snout, you must most surely come ashore; and many a good ship failing to round that point has beat up and down the bay all day, but come to beach in the evening. And once on the beach, the sea has little mercy, for the water is deep right in, and the waves curl over full on the pebbles with a weight no timbers can withstand. Then if poor fellows try to save themselves, there is a deadly undertow or rush back of the water, which sucks them off their legs, and carries them again under the thundering waves. It is that back-suck of the pebbles that you may hear for miles inland, even at Dorchester, on still nights long after the winds that caused it have sunk, and which makes people turn in their beds, and thank God they are not fighting with the sea on Moonfleet beach.

John Meade Falkner

SHIPWRECK

25 November 1872: Wind about SSW. Blowing very strong and on the night about five o'clock a large full rigged ship called the *Royal Adelaide* drove ashore and wrecked on Portland beach with 35 passengers on board and a crew of 32 men. She sailed from London on the 14 of November bound to Sydney in Australia with two thousand six hundred tons of General Cargo consisting brandy, rum, gin, cloth, cotton, sugar, paper, coffee and many other articles too numerous to mention. Three of the sailors and four passengers were drowned. For miles along the beach was lined with bails and boxes and pieces of her wreck. The *Royal Adelaide* was built of iron her mastes were iron and she was comparatively new. It appears that before she came ashore the Captain let bed her anchors

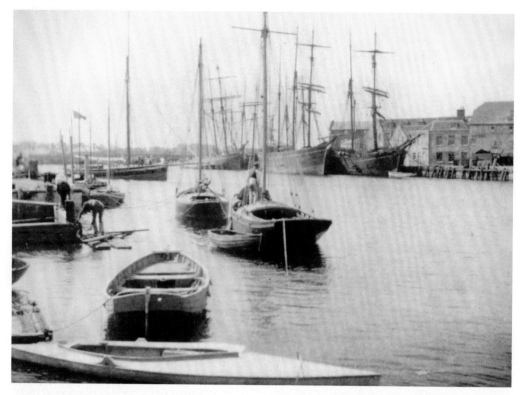

THE QUAY, POOLE

but they dragged and she struck broadside on. The same day a Schooner ran ashore and wrecked near Bridport with a cargo potatoes. All her crew was saved by the Lyme life boat in an exhausted state.

John Thomas Elliott

THE SEA FOX OF THRESHER—*SQUALUS VULPES*

A young specimen of this fish which is only occasionally met with on the British coast was captured by the Poole fishermen on Tuesday morning, near the north shore. It measured 8 feet 10 inches, the tail which is its most peculiar feature, being nearly four feet long and nearly one half of the size of the fish and into it the vertebral column is prolonged. It inhabits the Mediterranean sea, and is only occasionally found on our own coasts. The last one caught in Poole Harbour, was in June 1870. It grows to the length of thirteen feet, the tail being six feet. It is a most voracious and artful fish and derives its name of thresher from its supposed habit of attacking and threshing the grampus (a species of porpoise), with its fox-like tail. It belongs to the family of the dog fish and sharks, and would prove a rather unpleasant companion to a bather at the sand banks.

The Poole Sun, 29 June 1878

THE OLD CARRIER

Near where the Lovedays and Garlands of Mr Hardy's *Trumpet Major* gathered to witness the passing of George III, there used to linger an aged man and a child. Every day when the sky was clear he set out from an adjacent village with his granddaughter; while she stretched her tiny hands after the daisies, and held the buttercups beneath her chin 'to see if she liked butter', he sat on a flat stone by the wayside and waited. The main portion of his manhood had been spent in driving a carrier's van along the highway he haunted, the remainder in cracking stones. The man's attitude suggested his condition, his knarled hands bunched together as one who held the reins, his visage worn by its long exposure to the weather of every season, although it still bore traces of virility.

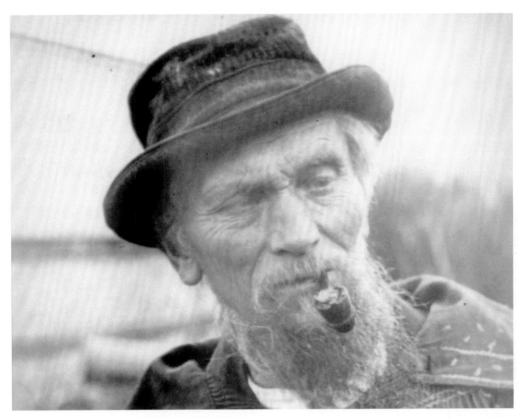

'WOLD MAN'

In early spring and late autumn an old friend worked on the flints on the other side of the road, every now and again pausing to speak a word to his aged comrade. After the ex-carrier had taken his seat for the afternoon, he gazed dreamily across the way, and greeted his companion thus:

'Arternoon, Willum; do they crackey well?'

A suitable response having been given to this inquiry, he sank into abstracted contemplation of the life that had been his own. Now, an up-to-date farmer would flash by in a smart dog-cart, a well-dressed lady beside him; two wizened faces would be raised to the sunlit dazzle of the spokes, and 'Hee, Hee' in wondering, derision would echo from one side of the road to the other. Or a young labourer footing it to the Georgian watering-place for an hour's gaiety would pass in his 'best blacks' garnished with a huge bunch of wallflowers and a variegated tie; and the twin chuckles would resound again. Any one who chanced to overhear the ensuing conversation between the two old men would have caught such phrases as: 'Times hev a-cheanged, sonny; when I wer a hard boy, Monday arternoon coorten wer unbeknown to the likes o' we.' When the market vans sleepily rolled down Ridgeway Hill the ex-carrier grew wistfully excited; his thin hands doubled into sinewy knots, and sparks like petrified flame suddenly glimmered in his eyes. On one of these occasions a driver reined up his van, and accosted the crouching figure thus: 'Ah, wold man, the roads will miss 'ee when you'm gone.'

Few outside his own order ever knew this old man, and strangers to the district would have found a difficulty in doing so. Comparatively few people ever take the trouble to detect interest beneath a fustian jacket, and some never dream of its existence. A fellow native belonging to a different sphere, desirous of becoming friendly with the aged carrier, would have found it advisable to don his shabbiest suit and discard all jewellery, and having removed artificial barriers, he would have been in a fair way to glean fragments of life which would have made him dream, had he any love and imagination in him. When the conversation had been opened up, it was easy to see the man's amazement at any one being deluded enough to fancy he was a person of interest. Some shyness then ensued—not the shyness of the young rustic of these days who thinks to himself, 'This here bloke might put I in a book'—but

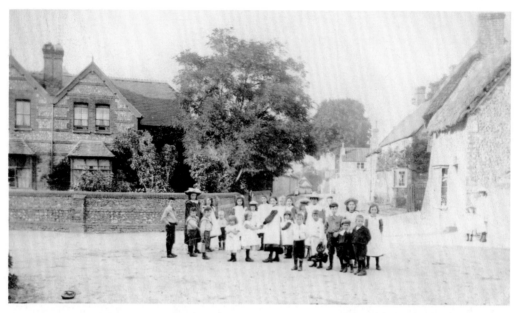

CHILDREN IN ROAD, STOURPANE

the shrinking born of some perception of the unfitness of detailing intimate concerns to a stranger. His tongue could only be forced over this barrier of modesty if the interlocutor happened to know of the ways of old country folk, their junketings at the ingathering of the harvest, christening parties, club walkings and Christmas dances; a surer way to reminiscences being to venture a happy remark about the experiences of a carrier. Anecdotes about the men and women he had carried would follow—how—'Tom Samwayes were a drawlatchten chap, who did never marry till his father-law that wer to be did ax en what 'ee did mean by car'ng on so wi' the maid if so be lawful matrimony accorden to Holy Church and Prayer Book wurden his meanin': Further, it would be told how 'Meary Angel never thoughted ar'n o' the maidens could come upsides wi 'er in zight o' the chaps till a strange maidy did sottle in the village, and if she were left to the coorten of Zammy Flail, the zilly carter:

Side by side with these recollections were memories of homeward journeys in the winter evenings, when 'the wheels o' the van got a-stooded in the snow, and the hedges were a zight for mortal eyes to see; they did look lik' long white ghostes, sure they did.' Most of his anecdotes contained pictures vividly sketched in the picturesque dialect of Wessex, developed to more dramatic issues, probably by the imagination which is the dowry of the race to which he belonged.

Contemplative silence usually contents the typical native; whether in his porch at evening, or seated with younger men in the village tavern, his thoughts take a long time to get launched on the stream of speech. Casual references to bygone customs such as Maypole dancing submerge him in a dream, and he meets the glowing description of some modern pastime with a deprecatory wave of his pipe and a derisive tongue of smoke. The old folks stand in the same relation to village life as a ruined abbey in the environs of a town;

MAN WITH HORSES, TINCLETON they are human curiosities valued as evidences of

CHILDREN AT RUINED CASTLE, SHERBORNE

change in the delights and privileges of a younger age. They possess quite a store of natural wisdom of a homely kind—their criticism of men and things generally falls short of modern perspicacity, but it is characterized by a shrewdness that is sometimes caustic.

It has been alleged with some amount of truth that morality is at a low ebb in the Wessex villages, though, like many other sweeping assertions, it is unfair in its inclusive condemnation. Compared with the ethical level of towns, it can safely be averred that the moral tone of Wessex villages is healthier, notwithstanding the potency of certain conditions which make for laxity. In judging our rustic character, the censorious critics should duly weigh the factors which militate against conventional ideas of seemliness, and should made due allowance for their age-long influence. Being familiarised with the world's tragedy, by long association with one of its chief sources in its aspect as the exercise of a primal function in the brute creation, the reaction of this intimacy upon the rustic mind is inimical to the highest standard of morality, and creates a tendency to condone a lapse from virtue.

The play of another quality, subtle in influence, possibly malign in results at crucial moments, must be duly considered before the peasants are sweepingly termed wilfully immoral. In face of the misfortunes incident to life, their attitude is almost Eastern in its fatalism. As a rule this attitude does not denote indifference, but the stoicism of those inured to fortune's vagaries; the danger of it being its proneness to weaken the power of resistance. Thus handicapped by an atmosphere intensely charged with menace to the Christian ideal of conduct, any attempt to judge the peasantry is partial and unjust, unless this mischievous bias is taken into consideration. Careful students of the Wessex novels will recognize the necessity for these remarks, though they would be equally apposite to any rural district.

Wilkinson Sherren

GUNPOWDER CLOT

At Fordington we had a great rough grass-field in which we played both cricket and football with infinite gusto but without any of the artificial burdens of level pitches or goalposts. At the top of the field screening it from the pleasant old long and low Vicarage were some noble elms. In the trunk of one there was a slight cavity at the base, and our minds being much set upon gunpowder at the period we decided to put some ounces into this hole and see what the effect of firing would be. I undertook the laying of a smouldering touchmatch, but it

'EDGON HEATH', LOOKING TOWARDS CREECH BARROW

went off prematurely in my face blowing off my hair and eye-brows, and for the time completely blinding me. I ran about the field shouting but was soon arrested, doubled up into a perambulator, and run up to West-Walks House. My aunt Ellen was stopping with us at the time and she and my mother were much concerned lest some permanent injury should have been done to my sight. Our two faithful doctors were sent for and while reserving their opinion sentenced me to bed in a darkened room for a few days.

John Meade Falkner

EGDON HEATH

A Saturday afternoon in November was approaching the time of twilight, and the vast track of unenclosed wild known as Egdon Heath embrowned itself moment by moment. Overhead the hollow stretch of whitish cloud

SANDY LANE, SHILLINGSTONE

shutting out the sky was as a tent which had the whole heath for its floor.

The heaven being spread with this pallid screen and the earth with the darkest vegetation, their meeting-line at the horizon was clearly marked. In such contrast the heath wore the appearance of an instalment of night which had taken up its place before its astronomical hour was come: darkness had to a great extent arrived hereon, while day stood distinct in the sky. Looking upwards, a furze-cutter would have been inclined to continue work; looking down, he would have decided to finish his faggot and go home. The distant rims of the world and of the firmament seemed to be a division in time no less than a division in matter. The face of the heath by its mere complexion added half an hour to evening; it could in like manner retard the dawn, sadden noon, anticipate the frowning of storms scarcely generated, and intensify the opacity of a moonless midnight to a cause of shaking and dread.

In fact, precisely at this transitional point of its nightly roll into darkness the great and particular glory of the Egdon waste began, and nobody could be said to understand the heath who had not been there at such a time. It could best be felt when it could not clearly be seen, its complete effect and explanation lying in this and the succeeding hours before the next dawn: then, and only then, did it tell its true tale. The spot was, indeed, a near relation of night, and when night showed itself an apparent tendency to gravitate together could be perceived in its shades and the scene. The sombre stretch of rounds and hollows seemed to rise and meet the evening gloom in pure sympathy, the heath exhaling darkness as rapidly as the heavens precipitated it. And so the obscurity in the air and the obscurity in the land closed together in a black fraternization towards which each advanced half-way.

The place became full of a watchful intentness now; for when other things sank brooding to sleep the heath appeared slowly to awake and listen. Every night its Titanic form seemed to await something; but it had waited thus, unmoved, during so many centuries, through the crises of so many things, that it could only be imagined to await one last crisis—the final overthrow.

It was a spot which returned upon the memory of those who loved it with an aspect of peculiar and kindly congruity. Smiling champaigns of flowers and fruit hardly do this, for they are permanently harmonious only with an existence of better reputation as to its issues than the present. Twilight combined with the scenery of Egdon Heath to evolve a thing majestic without severity, impressive without showiness, emphatic in its admonitions, grand in its simplicity. The qualifications which frequently invest the façade of a prison with far more dignity than is found in the façade of a palace double its size lent to this heath a sublimity in which spots renowned for beauty of the accepted kind are utterly wanting. Fair prospects wed happily with fair times; but alas, if times be not fair! Men have oftener suffered from the mockery of a place too smiling for their reason than from the oppression

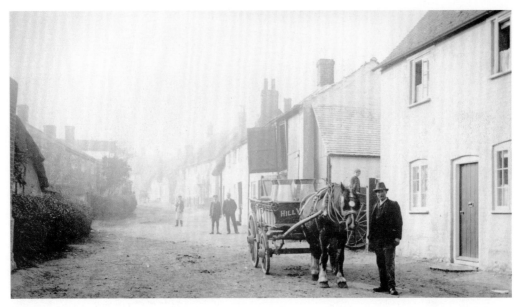

MILK-CART, OKEFORD FITZPANE

of surroundings oversadly tinged. Haggard Egdon appealed to a subtler and scarcer instinct, to a more recently learnt emotion, than that which responds to the sort of beauty called charming and fair.

Thomas Hardy

FIPPEN OKFORD DIGGENS

[Composed on the occasion of the report of minerals, including gold and silver, having been found at Okeford Fitzpaine.]

Here's work, my lads, agwaïn on,
I never yeard the Ilk;
They zay at Fippen Okford
There's goold in every crick;
An' mwore than that they zay bezides
There's lots o' cwoal an' iron,
An' 'twont be long avore we git
 A little cheäper virèn.

A man twold I vor zartin trooth
He digg'd a little while,
An' dra'd out lots an' lots o' goold—
Lor! how did meäke I smile,
I went straït hwome zo glad's a bird,
An' all the wav kep' hummen
Thik zong o' zongs I love zo well,
I mean 'The good time comèn.'

They zay 'twill turn things upzide down,
An' 'creas our popelashun,
An' varmets' work 'ull goo undone,
Their Ian's 'thout cultivashun.
But I cain't zee zo vur as that,
Noo Ian's 'll goo neglacted;
They'll plow an' zow, an' reap an' mow,
An' men'll be respacted.

Dig on, my lads; dig deeper down,
You'll vind zome hidden trasure,
The harder you do labour now,
Zome day you'll git mwore lasure;
An' if you don't vind lots o' goold,
But only cwoal an' iron,
We zhood be gratvul vor to have
A little cheäper virèn.

Robert Young (Rabin Hill)

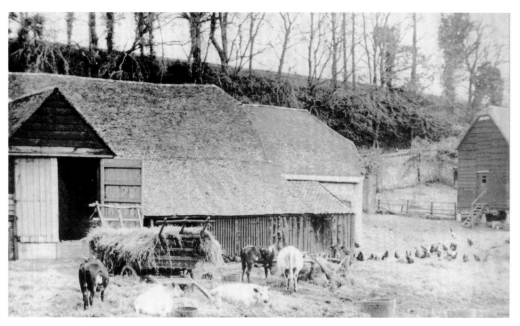

FARMYARD, TORY'S BARTON, TURNWORTH

RURAL MIGRATION: HARDY'S VIEW

The last evidence that I shall quote deals exclusively with the past and present position of the agricultural labourer in Dorsetshire. It will, I am sure, command universal attention and respect, having been given me by my friend, Mr Thomas Hardy, who as all the world knows, has made lifelong observation of this and kindred matters connected with the land.

Mr Hardy wrote to me in the spring of 1902: 'As to my opinion on the past of the agricultural labourer in this county, I think, indeed know, that down to 1850 or 1855 his condition was in general one of great hardship. I say in general, for there have always been fancy farms, resembling St Clair's estate in *Uncle Tom's Cabin*, whereon they lived as smiling exceptions to those of their class all around them. I recall one such, the estate owner being his own farmer, and ultimately ruining himself by his hobby. To go to the other extreme; as a child I knew by sight a sheep-keeping boy who, to my horror, shortly afterwards died of want, the contents of his stomach at the autopsy being raw turnip only. His father's wages were 6s. a week, with about £2 at harvest, a cottage rent free, and an allowance of thorn faggots from the hedges as fuel. Between these examples came the great bulk of farms, whereon wages ranged from 7s. to 9s. a week, and perquisites were better in proportion.

'Secondly, as to the present: things are of course widely different now. I am told that at the annual hiring-fair just past, the old positions were absolutely reversed, the farmers walking about and importuning the labourers to come and be hired instead of, as formerly, the labourers anxiously entreating the stolid farmers to take them on at any pittance. Their present life is almost without exception one of comfort, if the most ordinary thrift be

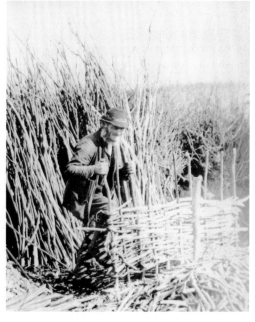

HURDLE-MAKING

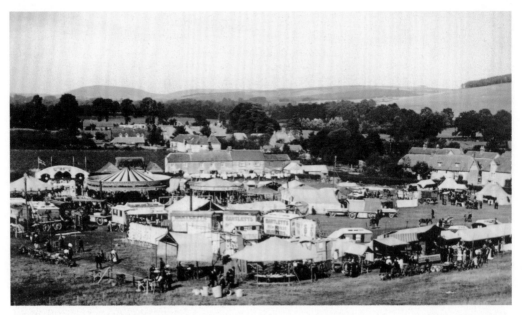

SHROTON FAIR

observed. I could take you to the cottage of a shepherd, not many miles from here, that has brass rods and carpeting to the staircase, and from the open door of which you hear a piano strumming within. Of course, bicycles stand by the doorway, while at night a large paraffin lamp throws out a perfect blaze of light upon the passer-by. The son of another labourer I know takes dancing lessons at a quadrille class in the neighbouring town.

'But changes at which we must all rejoice have brought other changes which are not so attractive. The labourers have become more and more migratory, the younger families in especial, who enjoy nothing so much as fresh scenery and new acquaintance. The consequences are curious and unexpected. For one thing, village tradition—a vast amount of unwritten folk-lore, local chronicle, local topography and nomenclature—is absolutely sinking, has nearly sunk, into eternal oblivion. I cannot recall a single instance of a labourer who still lives on the farm on which he was born, and I can only recall a few who have been five years on their present farm. Thus, you see, there being no continuity of environment in their lives, there is no continuity of information, the names, stories, and relics of one place being speedily forgotten under the incoming facts of the next. For example, if you ask one of the workfolk (they used always to be called "workfolk" hereabout; "labourers" is an imported word) the names of surrounding hills, streams, the character and circumstances of people buried in particular graves, at what spots parish personages he interred, questions on local fairies, ghosts, herbs, &c., they can give no answer; yet I can recall the time when the places of burial, even of the poor and tombless, were all remembered; the history of the squire's family for 150 years back was known; such and such ballads appertained to such and such localities; ghost tales were attached to particular sites; and secret nooks wherein wild herbs grew for the cure of divers maladies were pointed out readily.

'On the subject of migration to the towns I think I have printed my opinions from time to time, so that I will only say a word or two about it here. In this consideration the case of the farm labourers merges itself in the case of rural cottagers generally, including that of jobbing labourers, artisans, and nondescripts of all sorts who go to make up the body of English villagery. That these people have removed to the towns of sheer choice during the last forty years it would be absurd to say, except as to that percentage of young, adventurous, and ambitious spirits among them which is found in all societies. The prime cause of the removal is, unquestionably, insecurity of tenure. If they do not escape this in the towns, it is not fraught with such trying consequences to them as in a village, where they may have to travel ten or twenty miles to find another house and other work. Moreover, if in a town lodging an honest man's daughter should have an illegitimate child, or his wife take to drinking, he is not compelled to pack up his furniture and get his living elsewhere, as is, or was lately, too often the case in the

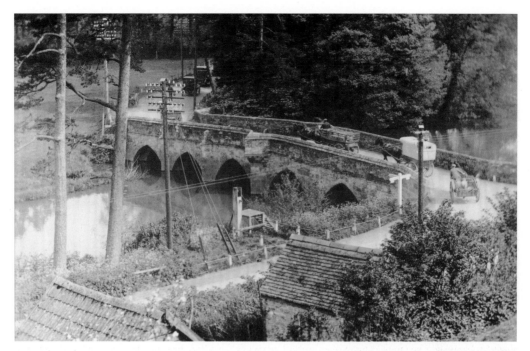

STURMINSTER NEWTON BRIDGE

country. (I am neither attacking nor defending this order of things; I merely relate it. The landlord sometimes had reason on his side, sometimes not.)

'Why such migrations to cities did not largely take place till within the last forty years or so is, I think, in respect of farm labourers, that they had neither the means nor the knowledge in old times that they have now. And they had not the inclination, owing to the stability of villagers of the other class, such as mechanics and small traders, who are the backbone of village life. The tenure of these latter was before that date a fairly secure one, even if they were not in the possession of small freeholds. The custom of granting leaseholds for three lives and other lifeholding privileges obtained largely in our villages, and though tenures by lifehold may not be ideally good or fair, they did at least subserve the purpose of keeping the native population at home. Villages in which there is not now a single cottager other than a weekly tenant, were formerly occupied almost entirely on the lifehold principle, the term extending over seventy or a hundred years; and the young man who knows that he is secure of his father's and grandfather's dwelling for his own lifetime, thinks twice and three times before he embarks on the uncertainties of a wandering career. Now, though, as I have said, these cottagers were not often farm labourers, their permanence reacted on the farm labourers, and made their lives with such associates richer in incident, better worth living, and more reluctantly abandoned.

'Thirdly, as to the future, and the ultimate results from such a state of things, it hardly becomes me to attempt to prophesy here. That remedies exist for them, and are easily applicable, you will readily gather from what I have stated above.'

Perhaps a further hint of what Mr Hardy considers to be the remedies that he does not actually specify in his letter, may be gathered by the perusal of an article on the Dorsetshire labourer, from which he has given me leave to quote, published by him in *Longman's Magazine* in 1883. In speaking of the peasant proprietors of Auvergne, and of the false conclusions that are drawn from the dirty and miserable condition of their dwellings, which lead the superficial observer into the error of supposing that slovenliness is necessarily accompanied by unhappiness, he says: 'But it must be remembered that melancholy among the rural poor arises primarily from a sense of the incertitude and precariousness of their position. Like Burn's field mouse, they are overawed and timorous lest those who could wrong them should be inclined to exercise their power. When we know that the Damocles' sword of the poor is the fear of being turned out of their houses by the farmer or squire, we may wonder how

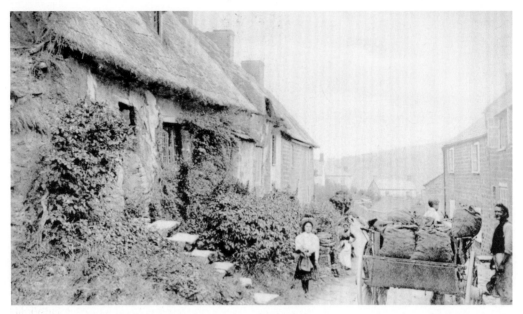

COAL DELIVERY, EYPE

many scrupulously clean English labourers would not be glad with half-an-acre of the complaint that afflicts those unhappy freeholders of Auvergne.'

Again, in writing of the depopulation of the villages, which even in 1883 he described as 'in some quarters truly alarming', and of the pulling down of the cottages of the lifeholders and other petty tenants who did not chance to be in the employ of the owners or farmers of estates as their leases fell in, he says: 'The occupants who form the backbone of village life have to seek refuge in the boroughs. This process, which is designated by statisticians as "the tendency of the rural population towards the large towns" is really the tendency of water to flow uphill when forced. The poignant regret of those who are thus obliged to forsake the old nest can only be realised by people who have witnessed it, concealed as it often is under the mask of indifference.'

I have no express authority for the opinion beyond that of the views which I have quoted; but I think that I am not wrong in concluding that Mr Hardy believes the best way to retain labourers and their families on the land is to give them some opportunity of securing, as owners or occupiers, an interest in the land.

I have now adduced a considerable body of evidence collected from authorities who are well able to judge of the agricultural conditions of the county, of the general purport of which the reader must form his own opinion. My personal conclusion is that unless the outlook has much changed since the year 1901—which I do not imagine to be the case—it is impossible to take a favourable view of the present prospects of the land, or of any class connected with it, in Dorsetshire.

H. Rider Haggard

THE RUINED MAID

'O 'MELIA, my dear, this does everything crown!
Who could have supposed I should meet you in Town?
And whence such fair garments, such prosperi-ry?'—
'O didn't you know I'd been ruined?' said she.

—'You left us in tatters, without shoes or socks,
Tired of digging potatoes, and spudding up docks;
And now you've gay bracelets and bright feathers three!'—
'Yes: that's how we dress when we're ruined,' said she.

DEWLISH

—'At home in the barton you said "thee" and "thou",
And "thik oon", and "theas oon", and "t'other"; but now
Your talking quite fits 'ee for high compa-ny!'—
'Some polish is gained with one's ruin,' said she.

—'Your hands were like paws then, your face blue and bleak
But now I'm bewitched by your delicate cheek,
And your little gloves fit as on any la-dy!'—
'We never do work when we're ruined,' said she.

—'You used to call home-life a hag-ridden dream,
And you'd sigh, and you'd sock; but at present you seem
To know not of megrims or melancho-ly!'—
'True. One's pretty lively when ruined,' said she.

—'I wish I had feathers, a fine sweeping gown,
And a delicate face, and could strut about Town!'—
'My dear—a raw country girl, such as you be,
Cannot quite expect that. You ain't ruined,' said she.

Thomas Hardy

A FEARFUL FALL

West Lulworth itself is the next point along the coast,
where is the famous and romantic cove known to so
many holidaymakers and 'steamer folk'. It is a white-
walled sea pool scooped out of the very heart of the
downs. The entrance to it from the Channel is a mere
breach in the cliff; which here rises straight from the sea.
Perched on a pinnacle on the eastern side of the entry is
the coastguard's look-out, while in a dip on the other side
are the scanty remains of the first Abbey of Bindon. The

HAYMAKING

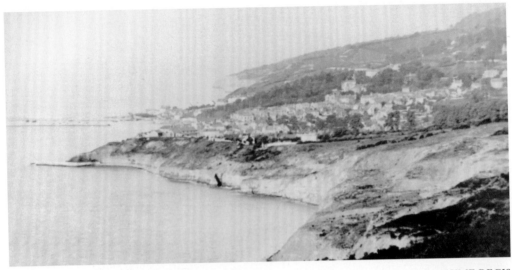

LYME REGIS

tide pouring in through the neck fills the pale cove with blue. Each wave spreads out into a widening circle as it nears the beach, so that the water viewed from the heights is rippled by concentric rings like the lid of a flat sea shell.

The cliffs that shut in the cove on the land side are steep and terrible. On the beach at the foot of the highest precipice is a board with this inscription on it:

> This marks the spot whereon
>
> E.H.L.
>
> Aged 11 years,
>
> Fell from the summit of the cliff,
>
> a descent of 380 feet,
>
> September 7th, 1892.
>
> She miraculously escaped without
>
> sustaining lifelong injury.
>
> S.T.S.L.

Any who look up from this spot to the fringe of grass which crowns this appalling wall will never for a moment credit that a child can have fallen from a height greater than that of St Paul's Cathedral without having been mangled to death. I did not actually see the poor girl fall, but I was on the beach when she was brought to the coastguard boat-house, where I was able to attend to her terrible injuries. She came down with her back to the cliff. Her clothes were torn into strings, and it would appear that the catching of her garment on the rough face of the precipice, together with the circumstance that certain slopes and ledges were encountered in her descent, help to explain the incredible fact that she escaped with her life, and still more happily without permanent ill effect. Those who are curious about coincidences may be interested to know that at the time the alarm reached my cottage I was reading a book written by her father. He was himself not staying in Lulworth at the time, nor had I previously made his acquaintance.

Sir Frederick Treves

WRECKS IN THE WAKE OF PROGRESS

Certain disabilities have attended the diffusion of knowledge among the peasantry. By it, the acquisition of natural lore has been stunted, native intelligence restricted by the discovery of short intellectual cuts, the desire for the artificialities of urban life engendered, love of the soil weakened, and a dialect as grand and ancient as any in the kingdom brought within measurable distance of extinction. Other changes have been brought about by the mutations of commerce, which have obliterated some of the industries wherein humble Wessex folk once

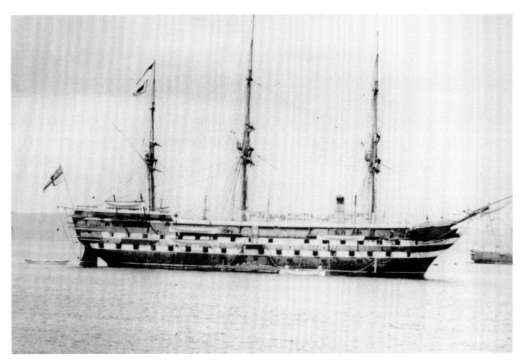

BOSCAWEN, PORTLAND

gained a livelihood. Decayed handicrafts that are now only a memory, at one time throve in various places. In former days the hum of the spinning wheel could be heard in many a cottage in Blackmore Vale, and the making of Honiton lace was carried on in Portland and elsewhere. Many a fine wooden ship was fashioned in the yards of the principal coast towns before the era of iron paralysed the trade and dispersed the workmen. These are only a few instances of the wrecks left in the wake of progress; they are eloquent of the period when industries were not monopolized by the iron fingers of machinery, and the work of the craftsmen formed as integral a part of his being as the threads of the silkworm.

Now, only the old people term young women 'maidens' or 'maidies'. Wherever possible, girls are sent from the villages to the towns and cities, there to be perverted with the shifting fashions and fancies of the great world, which they seek to reproduce on their return home. But the latest styles of holding a skirt or dressing the hair become obsolete ere they have percolated through the human strata to the village rank and file; nevertheless, the anachronisms of style are none the less pleasing on account of their novelty, there being no one, apparently, to put in a plea for fitness. The rustics have awakened to self-consciousness, and the recognition of their own peculiarities has warped their nature and interfered with its natural growth. Habits and customs, the deposit of centuries, are cast aside for the whims of an hour, because the quaint and steadfast country ways have been fretted by the fever of modern unrest. This aspect is mirrored in Mr T. Hardy's *The Woodlanders*, Grace Melbury being a typical example of the Wessex maiden in a state of transition, though the transmuting factors have grown in intensity since the period depicted in that novel.

How far education has fostered migration to the towns is a question beyond the scope of the present study; the assertion may be safely made, however, that the rustics who respond to the siren voice of the city are those who have been moulded by the newer influences. Not among this class is the characteristic peasant found. In nearly every village and hamlet there are 'granfers' and 'granmers', who are the repositories of the local traditions, and these are the true representatives of the Wessex peasantry. They were moulded by conditions which have been superseded, and being unwarped by the educational tendencies set in motion in 1870, they are the true exemplars of the old order, the natural human products of the soil they love.

Wilkinson Sherren

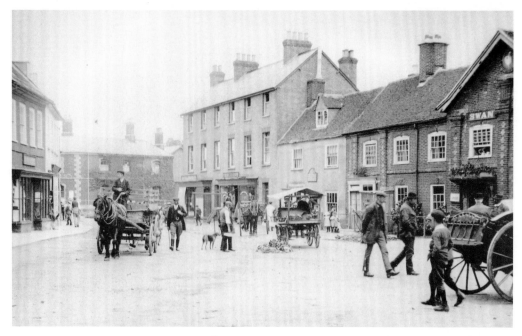

CARTS OUTSIDE SWAN HOTEL, STURMINSTER NEWTON

A BROTHEL

Elizabeth Standen (on bail) was indicted for unlawfully keeping and maintaining, within the last three months, a certain common, ill-governed, and disorderly house at Weymouth. Mr Ffooks-Woodforde prosecuted. William Cleall, of No. 4, Upway Street, Weymouth, said the prisoner occupied No. 3 in that thoroughfare. For the past three months he had seen prostitutes enter the house accompanied, for the most part, by sailors. Mary Jane Bendall said she had paid the prisoner money for occupying a bedroom at the house, she having men with her at the time.

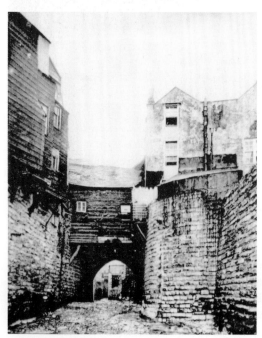

THE OLD BRIDGE, LYME REGIS

Three times the friends of witness gave the prisoner money. Three other girls were living there, getting their livelihood in the same manner. Witness, while in the house, had been living by prostitution. Maria Holland, another 'girl of the town', gave similar testimony. The prisoner, she said, knew perfectly well the purpose for which the money was paid. This evidence was partly confirmed by a police sergeant, who, on April 6th, visited the establishment, where he found four prostitutes in bed with men. Mr Cleall, recalled, said parties had called at No. 4 instead of No. 2, and he himself was a married man. The Deputy Judge said that the persons who adopted this mode of living were liable to prosecution for a nuisance to decent people. He could quite understand how Mr Cleall and others felt the gross insult. He had nothing to do with the immorality, but for punishment the accused must undergo three months' imprisonment. It was stated that the other parties whose names appeared in the calendar under a similar charge had fled to America.

Dorset County Chronicle and Somersetshire Gazette, 31 July 1873

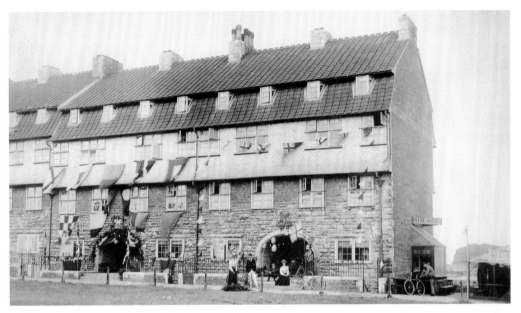

THE NORTH END OF PIER TERRACE, WEST BAY

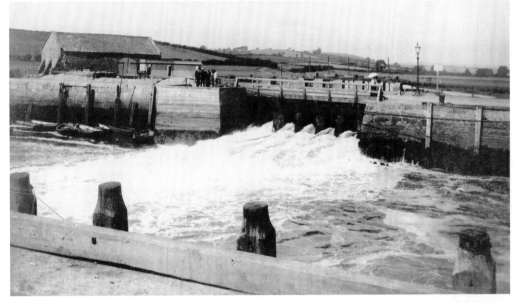

THE SLUICES, WEST BAY

ACCIDENTALLY POISONED

A distressing case of the poisoning of a clergyman's family is reported from Dorsetshire. At the latter end of last week, the wife and four children of the Revd T. A. Falkner of Weymouth were suddenly seized with illness which took the form of gastric fever (what we now call typhoid). Mrs Falkner has since succumbed to the disease and the children are scarcely expected to recover. It appears that on the day the family were taken ill a portion of a rat's tail was discovered in the water used for tea. The water had come from a tank which had been unused for sometime and the dead body of a rat was found there. The spring water generally used for the house was a distance off and the tank water was used by the servant as she was in a hurry at the time. The circumstance has cast quite a gloom over Weymouth.

The Times, Thursday March 16 1871

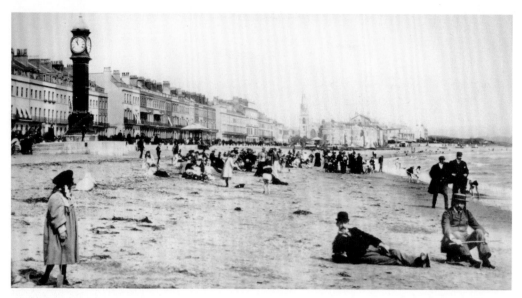

WEYMOUTH BEACH

CONCERNING MARRIAGE

Concerning marriage, many were the curious customs observed by Wessex maidens desirous of knowing who their future husbands would be. An even ash leaf having been plucked by the love-lorn girl, it was held alternately in the hand, the glove, and the bosom, the following couplets being recited:

> The even ash leaf in my hand,
> The first I meet shall be my man.
>
> The even ash leaf in my glove,
> The first I meet shall be my love.
>
> The even ash leaf in my bosom,
> The first I meet will be my husband.

At midnight on Old Midsummer's Eve, the scattering of hemp seed was practised with a like object. With a rake over the left shoulder the girl would walk in the garden, and throwing the seed over her right shoulder would repeat these lines:

> Hemp seed I set, hemp seed I sow,
> The man that is my true love come after me now.

If the spell worked properly, it was quite expected future husbands would instantly appear. A slight variant of this old-world custom is introduced into *The Woodlanders*. Atonement and penance are generally associated with Roman Catholic discipline, and it is unusual to find a penalty enforced to dissuade the younger members of a family from marrying before the elder. In one verified instance, where the seniors had permitted such a breach of the canons of propriety, they were compelled to dance barefooted over furze bushes placed on the floor on the day of the wedding.

There once existed a very stringent mode of discipline for those who had transgressed in their marital duties, known as 'Skimmington or Skimmity Riding', which pilloried the offenders, and provided a public spectacle in places where distractions were few. The *Bridport News*, in 1884, contained an account of this primitive method of punishment, in relation to the observance of it in the parish of Whitchurch Canonicorum. 'About six o'clock in the evening, just as darkness began to reign, a strange noise was heard, as of the sound of trays and kettles, and it was soon found that a "skimmity riding" was in progress, such a thing not having been known for years in this parish. Three grotesquely attired figures were to be seen escorted by a procession, consisting of persons dressed in various queer and eccentric costumes, who paraded the parish. . . . The persons alluded to appeared to the

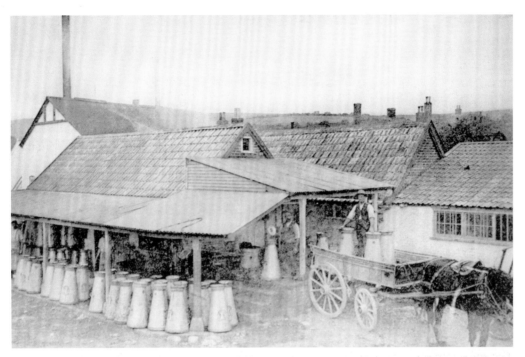

HILL VIEW DAIRIES, OKEFORD FITZPAINE

villagers to represent three personages who were very well known to them, there being a male and two females, whose past conduct had caused them to be the subject of this queer exhibition. (These figures were dummies.) One of the females was represented as having an extraordinarily long tongue, which was tied back to the neck, whilst in one hand she held some notepaper and in the other pen and holder. . . . After their perambulations were concluded, the procession retired to a certain field where a gallows was erected, and on which the effigies were hung and afterwards burnt, having previously been saturated with some highly inflammable liquid. . . . The extraordinary proceedings terminated with a fight, in which black eyes and bloody noses were not absent.' In the year of the above occurrence similar exhibitions took place at Okeford Fitzpaine and Weymouth.

Wilkinson Sherren

THE SUPERNATURAL—DREAMS AND HAUNTINGS

Belief in supernatural agencies has by no means died out; reputed witches are still living in a few villages, though the villagers are loth to speak about them. In one instance occult powers are supposed to run in a family residing in a village five miles from Dorchester. In the year of grace 1901 the following remark actually fell from the lips of the old lady under consideration: 'Well, as folk do say, I mid be a witch, but not such a girt one as my mother wer.' It is commonly reported in this village that a gentleman once living there, and now deceased, suffered from her spells. No villager cares to traverse a certain lane after nightfall, because of a jangle of chains and a clatter of hoofs, which are commonly thought to betoken the ghost of the bewitched gentleman in question taking nocturnal exercise.

The farmer to whom the remark just quoted was addressed is one of the old school, close-lipped, superstitious, and a pillar of the local chapel. One Sunday evening (towards the close of the nineteenth century), during the course of the service, he stopped in the singing of a favourite hymn. His daughter, who was playing the harmonium, noticed his unusual silence, and recognized the cause of it in the candles at her side, which had been burning unevenly, so as to make the globules of grease known as 'coffin handles', supposed to presage death; these she instantly pinched off, and the man at once continued to praise God with renewed energy. In his younger days this farmer made a similar journey to the one undertaken by the Mayor of Casterbridge when anxious about the harvest weather, but with a different object in view.

DEMOLITION OF ST MARY'S CHURCH, STRATTON

A litter of pigs had sickened, and no one could cure them. A visit to a 'wise man' informed him of an enemy who had 'overlooked' the animals, and in exchange for a gratuity a powder was given him to burn in the fire when the doors were closed for the night. The formula was carried out; blue flames sprang up the chimney, insistent knocks sounded without, and in the morning the pigs were healthily active.

On another occasion, when returning home from market one evening, through a meadow amid hills crowned with Celtic barrows, the old man said he heard strains of faint music, and saw the ground around him covered with battalions of phantoms, wheeling, advancing and retiring as if engaged in battle. This phenomenon cannot be dismissed as a dream brought about by free indulgence in stimulants, because the eye-witness of it has never taken alcohol in any form.

Of the malignancy of witches, a man of Winterbourne Houghton used to bear striking testimony, for he incurred the displeasure of one of the sable sisterhood, by refusing her demand for money. Instantly she cast a spell upon him, so he said, and told him he would never prosper from that time forth, and that 'horses would bring him to ruin.' Soon after this prophecy, one of his steeds sickened and died, the same fatality overtaking the others before the lapse of many weeks. Strange to say, disease and accident happened to every animal he bought, until at last, reduced to poverty by his losses, he could buy no more. From his garden one morning he saw his son's horse take fright and drag a load of faggots behind it down a hill. Thinking to stop the animal, he ran to its head, but only

BULL-BAITING STONE, STINSFORD HILL

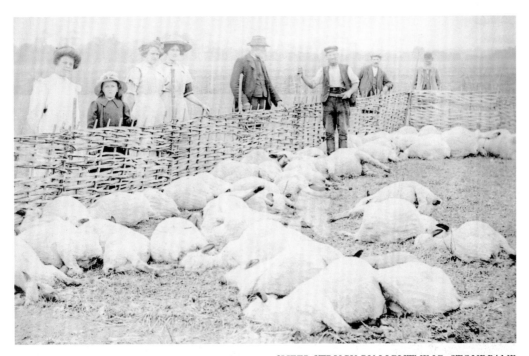

SHEEP STRUCK BY LIGHTNING, STOURPANE

to be knocked down, the wheels of the waggon passing over his leg and severely crushing it. He lingered for some months, but finally succumbed to his injuries, thus fulfilling the prophetic words that 'horses would be his ruin.' Another man who thought he was bewitched, melted a threepenny piece and made a silver bullet to shoot the dame who had 'overlooked' him. Passing homeward one day, a fine hare sprang across the road, and he bemoaned the fact that he had not his bullet with him, or he would have destroyed the evil influence by killing the witch, who he believed was there masquerading as a hare. Still another way of nullifying the occult potency was to draw blood from the body of the 'wise woman', a method of procedure adopted by Susan Nonsuch in *The Return of the Native* when she pricked Eustacia Vye with a pin. Almost a parallel instance occurred at Winfrith, where a defenceless old dame was assaulted in the same way under the belief that it would stultify her spells.

Evil significance is read into the inopportune conduct of birds and beasts, such as the tapping of a bird on the windowpane, and the crowing of cocks at unusual hours, the sinister suggestion of this fact being remarked upon by Dairyman Crick, on the departure of Tess and Angel Clare for their honeymoon visit to Wellbridge. The same apprehension was also expressed by a countrywoman in these term: 'If the cock do crow after twelve o'clock noon, her is doing it to bring I bad news, or John may be bad agean. I can't a-bear to hear'n.' If bees swarm on the branches of a tree it is a token of death, the untimely flowering of apple blossom having the same dire import. The belief in the possibility of communication—mostly in the form of visual manifestations—between the lives that are and were in the body is fairly general. Notwithstanding the tendency to enlarge the horizon of average experience by the exercise of the imagination, instances of strange events have been recorded and verified; these strengthen the opinion that the living and the dead reside in the same orbit, and can occasionally communicate. In Portland there is a house narrowly observed because of a supernatural episode connected with it. Here, a man in perfect health and sanity of mind awakened at midnight in the darkness, and knew that two figures were on either side of him, though did not see them. A voice spoke, in echo-like tones, saying the time had come for him to depart this world. It filled him with fear; nevertheless, he managed to crave a respite, saying his spiritual condition unfitted him for any realm but an earthly one, and he was granted twelve hours' grace. Though iron-nerved and courageous, this experience greatly troubled the man, who told a neighbour of it before he set out for work next morning. Towards noon he went on an errand, and in due course arrived home for the dinner he never ate, for death met him in the way ere the last strokes of twelve had struck.

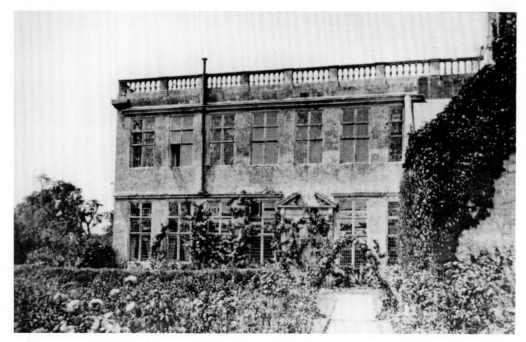

GARDENS, KINGSTON RUSSELL

Fifty years ago the fireside hours in the village of Winfrith were beguiled by a gruesome story.

It told of a certain villager who set out for the market town one evening on business of some urgency. His wife sped him on his way, and then 'hapsed' the door and retired to rest with the assurance of her husband ringing in her ears, that he would be home by noon the next day. Noon passed, and the sun had neared the horizon; in the village street the woman stood anxiously looking for the lagging man. She continued to peer up the roadway till its white outline disappeared in the gloom.

Another hour of waiting brought the darkness; suddenly she was aroused by the sound of approaching footsteps, and, rushing to the door, she was surprised to find no one pass. She returned to her room, and once more recognised her husband's footfall, though the steps never came to the threshold. The sound repeatedly emerged on the silence and died away, till, full of dim forebodings, the woman consulted two neighbours, who went into the forsaken cottage, and listening, distinctly heard the footsteps of one unseen. Then one of them retired and whispered to the neighbours who had collected; lanterns glimmered, and a search party went out into the night to follow the spectral footfall. It led them to a disused well, and the light flashing to the bottom of it revealed the distorted figure of a corpse, recognised as the man who the day before had gone to the market town.

Faith in dream warnings is very strong, and some striking proofs of their fulfilment can be adduced. For instance, a certain woman dreamt three times that her husband met with an accident and cut his arm. This so impressed her that she told him of it, and before he set out for the fields the next morning, gave him a roll of white rag 'in case anything happened'. After mowing all the morning, he and the other men sat down to their 'nunch'. When they had finished he told them his wife's dream, and upon rising to continue his labour accidentally trod on the handle of his scythe, the blade of which flew up and struck his arm, severing the radial artery and exactly fulfilling his wife's apprehensions.

Wilkinson Sherren

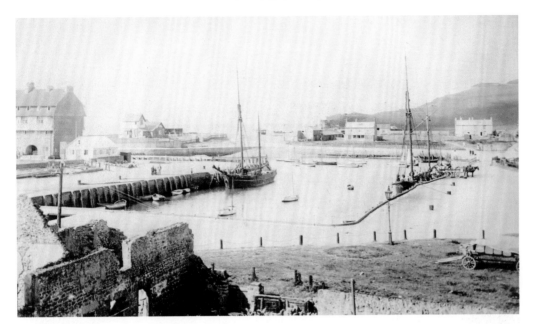

WEST BAY

SWANAGE BAY

To the Editor of The Times—Sir,—The wreck of the *Wild Wave* on Peveril Ledge, though a grievous loss to one individual—the poor uninsured owner—has, thanks to the publicity given to it in *The Times*, resulted in unmixed gain to the seafaring interest. The Swanage lifeboat will, in a few weeks, be an established institution, and you have lately announced the fact that a lighthouse is to be placed on Durlstone Head. Many a good ship and scores of lives might have been saved had the warning beacon been established say 50 years ago; but there is yet one thing more to be done—more important still is that artificial shelter for vessels should be provided in Swanage Bay. There is at present no safe refuge for ships on the mainland coast between Portland and the Solent, a distance of upwards of 40 miles, and the urgent need of it is matter of every-day experience.

It is the opinion of some of the highest naval authorities, long ago publicly expressed, that a breakwater should be constructed at Swanage Bay, which would thereby be converted into one of the finest and most useful harbours of refuge in the Kingdom.

There is scarcely a man, woman, or child along the Purbeck coast to whom some heart-rending occurrence or other is not present in mind, owing to the fatal lack of shelter. Some years ago on one afternoon six ships and 30 poor mariners were lost, almost under the eyes of the Swanage and Studland people, though every one, ships and men, would have been saved if the merest heap of stones even in the form of a breakwater had been in existence. Yet the entire Isle of Purbeck is a mass of the finest and most suitable building stone, and a few thousand pounds even would suffice to throw as much of it into the sea as would prove of incalculable use and benefit.

Just a few more lines and I have done. Swanage Bay is the only place for 40 or 50 miles, in the very centre of the South coast, where a large invading Army might be safely landed; it is the natural port of a vast natural fortress, almost a direct parallel to the famous Torres Vedras corner of Portugal, and if ever an enemy with command of the sea got possession of the district all the Armies of Europe might not be able to drive them out again; but situated as it is in the very heart of this maritime country, it is simply one of the most unguarded and altogether neglected places in the British Isles.

I am, Sir, your obedient servant,

J. G. ROBINSON
10, York-place, Portman Square

The Times 25 March 1875

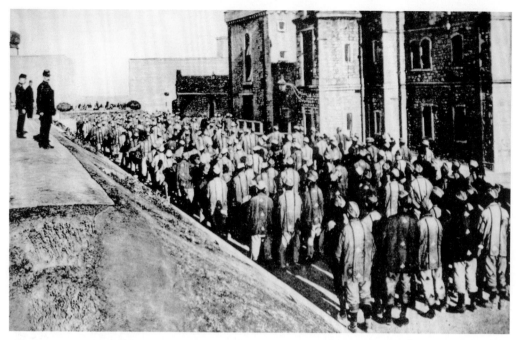

CONVICTS RETURN FROM WORK, COUNTING IN, PORTLAND

QUARRYMEN'S STRENGTH

In the stone-trade there are men who, with very little practice, could compete with all the tricks of weight-lifting and similar ways of showing great strength. I have friends in Purbeck who have never trained themselves in any way except in work, yet they can lift a quarter of a ton, and in the ordinary course of their work they lift stones of two and three hundred-weight all day long without lying back and being attended to by trainers and seconds between lifts.

PRISON GATEWAY, PORTLAND

My father never claimed to be a strong man, yet once when he was ill I undertook to do his work of loading stone at the railway station until he was about again. At the end of the first day I had reason to look through the list of stone I had put into trucks, and found that it amounted to forty-five tons, every bit of which had to be lifted at least once and carried a few steps, and much of it moved several times. I was young and in pretty good order, but I thought of him having carried on in that way until he was really ill. He was no longer young, and was crippled to a certain extent; yet that was his ordinary day's work. Probably there were days when he handled much more, when things were running smoothly, without delays, because I found there was plenty of time to stand about and get chilled between the arrivals of the lorries. What professional strong man could carry on under such conditions?

Eric Benfield

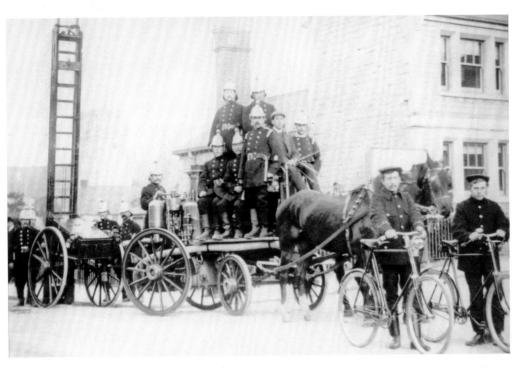

FIRE BRIGADE, SWANAGE

BLANDFORD CAMP

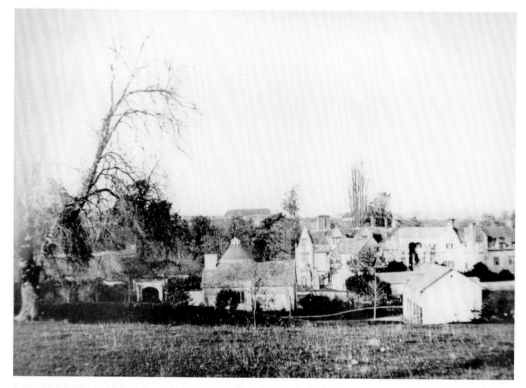

ATHELHAMPTON

THE RING AT CASTERBRIDGE

The Ring at Casterbridge was merely the local name of one of the finest Roman Amphitheatres, if not the very finest, remaining in Britain.

Casterbridge announced old Rome in every street, alley, and precinct. It looked Roman, bespoke the art of Rome, concealed dead men of Rome. It was impossible to dig more than a foot or two deep about the town fields and gardens without coming upon some tall soldier or other of the Empire, who had lain there in his silent unobtrusive rest for a space of fifteen hundred years. He was mostly found lying on his side, in an oval scoop in the chalk, like a chicken in its shell; his knees drawn up to his chest; sometimes with the remains of his spear against his arm, a fibula or brooch of bronze on his breast or forehead; an urn at his knees, a jar at his throat, a bottle at his mouth; and mystified conjecture pouring down upon him from the eyes of Casterbridge street boys and men, who had turned a moment to gaze at the familiar spectacle as they passed by.

Imaginative inhabitants, who would have felt an unpleasantness at the discovery of a comparatively modern skeleton in their gardens, were quite unmoved by these hoary shapes. They had lived so long ago, their time was so unlike the present, their hopes and motives were so widely removed from ours, that between them and the living there seemed to stretch a gulf too wide for even a spirit to pass.

The Amphitheatre was a huge circular enclosure, with a notch at opposite extremities of its diameter north and south. From its sloping internal form it might have been called the spittoon of the Jötuns. It was to Casterbridge what the ruined Coliseum is to modern Rome, and was nearly of the same magnitude. The dusk of evening was the proper hour at which a true impression of this suggestive place could be received. Standing in the middle of the arena at that time there by degrees became apparent its real vastness, which a cursory view from the summit at noon-day was apt to obscure. Melancholy, impressive, lonely, yet accessible from every part of the town, the historic circle was the frequent spot for appointments of a furtive kind. Intrigues were arranged there; tentative meetings were there experimented after divisions and feuds. But one kind of appointment—in itself the most common of any—seldom had place in the Amphitheatre: that of happy lovers.

SCHOOL-ROOM INTERIOR, ENMORE GREEN, SHAFTESBURY

Why, seeing that it was pre-eminently an airy, accessible, and sequestered spot for interviews, the cheerfullest form of those occurrences never took kindly to the soil of the ruin, would be a curious inquiry. Perhaps it was because its associations had about them something sinister. Its history proved that. Apart from the sanguinary nature of the games originally played therein, such incidents attached to its past as these: that for scores of years the town-gallows had stood at one corner; that in 1705 a woman who had murdered her husband was half-strangled and then burnt there in the presence of ten thousand spectators. Tradition reports that at a certain state of the burning her heart burst and leapt out of her body, to the terror of them all, and that not one of those ten

thousand people ever cared particularly for hot roast after that. In addition to these old tragedies, pugilistic encounters almost to the death had come off down to recent dates in that secluded arena, entirely invisible to the outside world save by climbing to the top of the enclosure, which few townspeople in the daily round of their lives ever took the trouble to do. So that, though close to the turnpike-road, crimes might be perpetrated there unseen at mid-day.

Some boys had latterly tried to impart gaiety to the ruin by using the central arena as a cricket-ground. But the game usually languished for the aforesaid reason—the dismal privacy which the earthern circle enforced, shutting out every appreciative passer's vision, every commendatory remark from outsiders—everything, except the sky; and to play at games in such circumstances was like acting to an empty house. Possibly, too, the boys were timid, for some old people

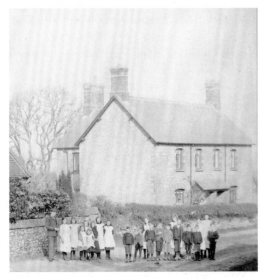

RYME INTRINSECA

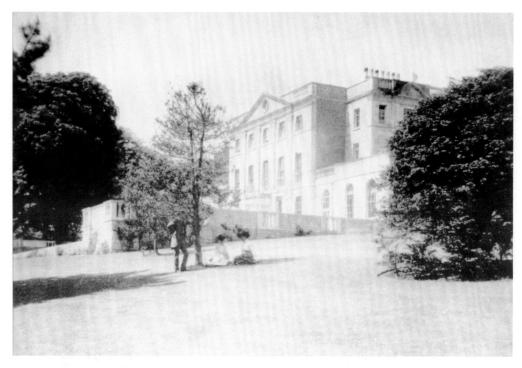

DOWNE HALL, BRIDPORT

said that at certain moments in the summer time, in broad daylight, persons sitting with a book or dozing in the arena had, on lifting their eyes, beheld the slopes lined with a gazing legion of Hadrian's soldiery as if watching the gladiatorial combat; and had heard the roar of their excited voices; that the scene would remain but a moment, like a lightning flash, and then disappear.

It was related that there still remained under the south entrance excavated cells for the reception of the wild animals and athletes who took part in the games. The arena was still smooth and circular, as if used for its original purpose not so very long ago. The sloping pathways by which spectators had ascended to their seats were pathways yet. But the whole was grown over with grass, which now, at the end of summer, was bearded with withered bents that formed waves under the brush of the wind, returning to the attentive ear Æolian modulations, and detaining for moments the flying globes of thistledown.

Thomas Hardy

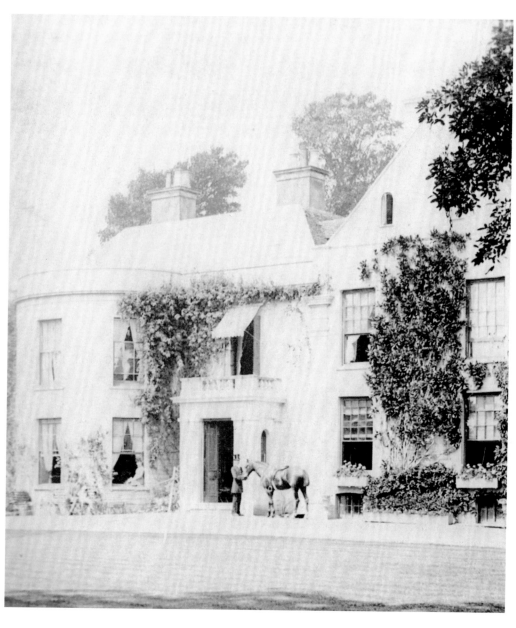

SHROTON HOUSE

GOLDEN JUBILEE, WEST BAY

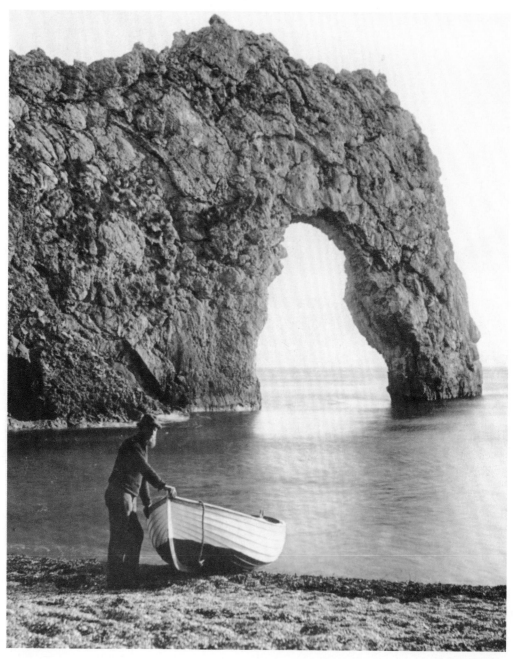

DURDLE DOOR

SWANAGE FISHERMEN

SUNDAY SCHOOL TRIP, SWANAGE

CORFE CASTLE

HARVESTING, TOLPUDDLE

SOURCES

Diary extracts and other unprinted material come from the Dorset County Record Office (DCRO), and are reprinted by kind permission of the County Archivist.

Sources of the text are as follows: John Meade Falkner *Notes on Life in West Walks, Dorchester, 1859–1871* (DCRO); *Constance Weld Diary* (DCRO); Thomas Hardy *The Complete Poems*; Aubrey Strahan *Guide to the Isle of Purbeck*; Thomas Hardy *'FellowTownsmen'* (*Wessex Tales*); H. Rider Haggard *Rural England, Being an Account of Agricultural and Social Researches Carried Out in the Year 1901 & 1902*; Robert Young ('Rabin Hill') *Poems in the Dorset Dialect*; Thomas Hardy *The Mayor of Casterbridge*; Wilkinson Sherren *The Wessex of Romance*; Thomas Hardy *'The Withered Arm'* (*Wessex Tales*); Burton Bradstock *Parish Magazine* (DCRO); Eric Benfield *Southern English*; *The Poems of William Barnes*; William Allingham *Diaries*; Dr Buchanan's *Report on the Sanitary State of Bridport, 1864* (DCRO); Thomas Hardy *The Return of the Native*; Llewelyn Powys *Dorset Essays*; Sir Frederick Treves *Highways and Byways in Dorset*; Wynne Albert Banks *Diary 1840–1912* (DCRO); Broadsheet printed by Prince of Bridport (DCRO); John Thomas Elliott *Diary* (DCRO); John Meade Falkner *Moonfleet*.

Newspapers include: *Dorset County Chronicle* and *Somersetshire Gazette*; *Western Gazette*; *Wareham and Isle of Purbeck Advertiser* and *Swanage Visitors List*; *The Beehive*; *The Poole Herald*; *The Poole Sun*; *The Times*. Extracts were taken from cuttings held in the Local Studies Collection, Dorchester Reference Library, and are reprinted by kind permission of the County Librarian.

The illustrations have been provided by Dorset County Museum (most photographs from either Powell or Pouncy collections); Studio Edmark, Oxford; Simon Rae Author Collection and from Arthur Watson.

2